A BIGGER MESSAGE

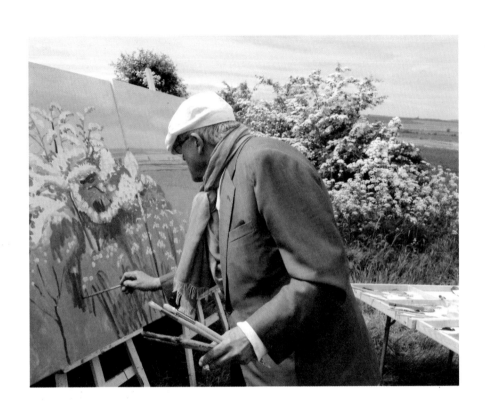

Martin Gayford

A BIGGER MESSAGE

Conversations with David Hockney

with 161 illustrations, 154 in colour

On page 2:
David Hockney painting *Woldgate Before Kilham*, 2007

First published in the United Kingdom in 2011 by
Thames & Hudson Ltd,
181A High Holborn, London WC1V 7QX

A Bigger Message: Conversations with David Hockney
copyright © 2011 Thames & Hudson Ltd, London
Text copyright © 2011 Martin Gayford
Works by David Hockney copyright © 2011 David Hockney

Designed by Karolina Prymaka

British Library Cataloguing-in-Publication Data
A catalogue record for this book is available
from the British Library

ISBN 978-0-500-23887-5

Printed in China by C&C Offset Printing Co. Ltd

To find out about all our publications, please visit
www.thamesandhudson.com. There you can subscribe to our
e-newsletter, browse or download our current catalogue,
and buy any titles that are in print.

CONTENTS

Introduction: Turner with an iPhone PAGE 6

1 *A Yorkshire paradise* PAGE 12

2 *Drawing* PAGE 34

3 *The trap of naturalism* PAGE 42

4 *The problems of depiction* PAGE 54

5 *A bigger and bigger picture* PAGE 64

6 *Scale: a bigger studio* PAGE 76

7 *Seeing more clearly* PAGE 82

8 *Drawing on a telephone and in a computer* PAGE 88

9 *Painting with memory* PAGE 101

10 *Photography and drawing* PAGE 115

11 *Caravaggio's camera* PAGE 126

12 *Way out west: space exploration* PAGE 136

13 *Cleaning Claude* PAGE 146

14 *Movies and moving through the landscape* PAGE 156

15 *Music and movement* PAGE 166

16 *Van Gogh and the power of drawing* PAGE 182

17 *Drawing on an iPad* PAGE 191

18 *The power of images* PAGE 201

19 *Theatre* PAGE 207

20 *Lighting* PAGE 216

21 *Nine screens on Woldgate* PAGE 229

David Hockney's life and work PAGE 236 | *Further reading* PAGE 240

List of illustrations PAGE 241 | *Note on the text* PAGE 245 | *Acknowledgments* PAGE 245

Index PAGE 246

Introduction
Turner with an iPhone

One morning in the early summer of 2009, I got a text from David Hockney: 'I'll send you today's dawn this afternoon. An absurd sentence I know, but you know what I mean.' Later on it duly arrived: pale pink, mauve and apricot clouds drifting over the Yorkshire coast in the first light of a summer's day. It was as delicate as a watercolour, luminous as stained glass, and as high-tech as any art being made in the world today. Hockney had drawn it on his iPhone.

The location of this sunrise was the north-east coast of England. For much of the last seven years, Hockney has been living in the seaside town of Bridlington, after having spent the previous quarter of a century based in Los Angeles. During the dark part of winter in East Yorkshire, the day length is short; in high summer, it begins to get light in the early hours of the morning. Hockney exulted in the early morning glory over the North Sea in another text (he is as fluent a texter as any teenager): 'Would Turner have slept through such terrific drama? Absolutely not! Anyone in my business who slept through that would be a fool. I don't keep office hours.'

The text and the little dawn landscape were both messages from Hockney, one verbal and one visual. He communicates by word and by image, and almost everything he has to say in each is worthy of attention. This is a book of conversations with the artist, discussions that have lasted a decade, increasingly long and wide-ranging. The subject was usually pictures – that is, man-made images of the world. He considered them from many points of view: historical, practical, biological, anthropological.

Untitled, 5 July 2009, No. 3, iPhone drawing

The earliest of our talks took place ten years ago; the latest, just a week ago as I write. So the text is made up of layers – a favourite word of Hockney's. He stresses the different washes that make up a watercolour, the coats of ink in a print, the strata of observation through time in a portrait. The words in these pages have accumulated in a similar fashion over months and years, exchanged by a variety of media old and new: telephone, email, text, sitting face to face talking in studios, drawing rooms, kitchens and cars. Many of the thoughts are Hockney's, but the arrangement is mine. It's a snapshot of a moving object: what he has thought and said towards the close of the first decade of the twenty-first century.

Hockney tells an anecdote about a dinner party he once attended in Los Angeles. Another guest had posed a question: 'Are you a Constable or a Turner man?' 'I thought, "OK, what's the catch?" So I asked her what the answer was. She said, "Constable painted the things he loved, and Turner went in for spectacular effects." I said, "But, Turner *loved* spectacular effects."'

Hockney loves them too, but like Constable he has returned to paint the landscape of his youth. Constable found many of his greatest subjects in his native village of East Bergholt in Suffolk. In the early twenty-first century, Hockney has gone back to the rolling hills of the Yorkshire Wolds, which he first explored as a teenager. He has drawn them on paper, iPhone and iPad, painted them, and latterly filmed them simultaneously through nine high-definition movie cameras. This creates another kind of spectacular visual experience, one never seen before in the history of art.

In other words, Hockney has been using very novel methods to tackle some of the perennial themes of art: trees and sunsets, fields and dawns. The problems of painting and drawing these things were familiar not only to Turner and Constable, but also to Claude Lorrain in the seventeenth century. Their challenges are Hockney's too: how can one translate a visual experience such as a sunrise – a fleeting event involving expanses of space, volumes of air, water vapour and varying qualities of natural light – into a picture? How do you compress all that into some flat coloured shapes on an iPhone or anything else?

A picture, any picture, if you consider it for a moment, depends on several remarkable procedures. It stops time, or if it is a moving picture, it edits and alters time. Space is flattened. The subjective psychological reactions and knowledge of both the person who made it and the one who looks at it are crucial to the way it is understood.

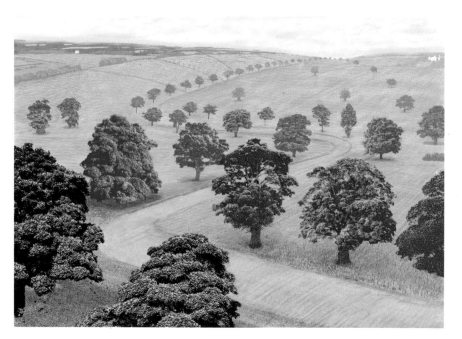

Green Valley, 2008

The savants of the eighteenth century were much exercised by the question of what a person blind from birth, whose sight was suddenly restored, would make of the visible world. Amazingly, the experiment was actually performed. In the 1720s, William Cheselden, a London surgeon, removed the cataracts from the eyes of a thirteen-year-old boy. The latter gradually came to associate the objects he had known only through touch with what he now saw. One of the last puzzles he solved was that of pictures. It took two months, 'to that time he consider'd them only as Party-coloured Planes, or surfaces diversified with Variety of paint'. And that of course is exactly what pictures are, but they fascinate us and help us understand and enjoy what we see.

All good artists make the world around us seem more complex, interesting and enigmatic than it usually appears. That is one of the most important things they do. David Hockney is unusual, however, in the range, boldness and verve of his thinking. A while ago, he sent a book to a friend of his who was in prison in the United States. It was a thick *History of Architecture* by Sir Bannister Fletcher, much thumbed and characteristically admired by Hockney for its beautifully lit photographs, but intended as a work of reference. There was a long silence from Hockney's jailed associate. Then, eventually, there came a response. It turned out that in his cell he had been working through the entire tome from cover to cover and finally announced, 'That's the first history of the world I've ever read.' Hockney was intrigued by this response and thought it over. 'In a way', he concluded, 'if it's a history of the world's buildings, it *is* a history of the world's changing power and people.'

Something similar is true of Hockney's own central obsession. His abiding preoccupation is what the world looks like, and how human beings represent it: people and pictures. It is a wide question, and a deep one, and it's the subject of this book.

DH I suppose essentially I am saying we are not sure what the world looks like. An awful lot of people think we do, but I don't.

MG So you believe it's a mystery that can still be explored and, what's more, that it always will be?

DH Yes, it will. A two-dimensional surface can easily be copied in two dimensions. It's three dimensions that are hard to get onto two. That involves making a lot of decisions. You have to stylize it or something, interpret it. You've got to accept the flat surface. Not try and pretend it's not there. Doesn't that mean that we learn how to get used to pictures and interpret them? And isn't that one reason why we are fascinated by pictures? I certainly am. I've always believed that pictures make us see the world. Without them, I'm not sure what anybody *would* see. A lot of people think they know what the world looks like because they've seen it on television. But if you are deeply fascinated by what the world really looks like, you are forced to be very interested in any way of making a picture that you come across.

I

A Yorkshire paradise

DH I'm not sure which modernist critic said that it wasn't
possible to do anything with landscape any more.
But when people say things like that I'm always perverse
enough to think, 'Oh, I'm sure it *is*.' I thought about it,
then I decided that it couldn't be true because every
generation looks differently. Of course you can still paint
landscape – it's not been worn out.

My first visit to see David Hockney in Bridlington was in
September 2006. Not only had I never been there before, I had
never heard of anyone else doing so either. It's so northern
and unfashionable as to be positively exotic. I changed trains at
Doncaster and again at Hull. It was a slow and surprisingly long
journey. On a recommendation from Hockney's friend and assis-
tant David Graves, I had booked a room at the Expanse Hotel –
aptly named, since at low tide it commands a view over a vast
stretch of eastward-facing beach, with the white cliffs of
Flamborough Head in the distance to one side, and the cold flat
mass of the North Sea extending to the horizon.

While I was having breakfast the following morning,
Hockney and his assistant Jean-Pierre Gonçalves de Lima
appeared both looking dapper (Hockney himself in a check suit
and cap), having driven over from Hockney's home a couple
of miles away at the other end of the beach and the long, long
seafront promenade. This house of Hockney's turned out to be
the nicest building in the whole town, chosen with an artist's
eye. His mother and sister Margaret used to live here, now

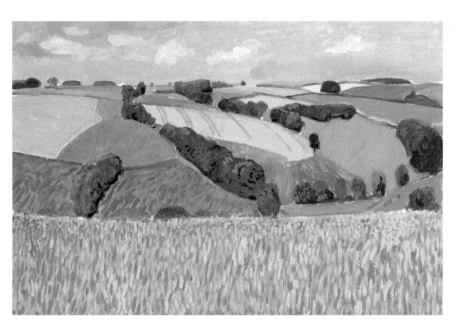

Fridaythorpe Valley, August 2005

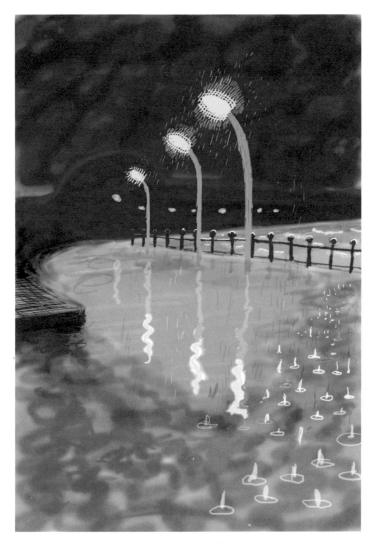

Rainy Night on Bridlington Promenade, 2008

the latter has moved round the corner. It is substantial, brick-built, bay-windowed, and dates – at a guess – from the 1920s. Previously it had been a small hotel, and some of the rooms still have numbers above the doors, Hockney not having got round to removing them. The place exudes a sense of solid comfort; the upper landing curves round the hall with white-painted banisters in the way one sees in the sets of old Hollywood films.

DH I love that we're just by the sea here. When you walk out of my door, there's a great big space there. It makes me feel good when I go out for a walk on the beach. Beside the sea at Bridlington, my sister once said, 'Sometimes I think space is God.' That's a very nice, poetic idea.

Almost immediately, we were off in a zippy little convertible, on a quick flip round the countryside so that I could see the places he had been painting. 'We think we've found a paradise here', he remarked of the landscape inland from Bridlington, meaning by 'we' himself, his partner John Fitzherbert and Jean-Pierre (otherwise known as J-P): in other words, the Hockney household. Jean-Pierre, Hockney pointed out, was the only Parisian currently resident in Bridlington. In a previous existence, J-P was an accordion-player. He had now become, it seemed, a keen observer of East Yorkshire life.

DH At the moment, this is the place for me. I've got two friends who live here too, and they like this rather quiet spot. John runs the house – he's a very good cook – and J-P became fascinated by the English provinces. He's a musician, but over the last few years he's developed quite an eye, and he's become almost as passionate about observing the landscape as I have. He began to see what I was seeing, how fascinating it was, how nature was

constantly changing and moving. I couldn't have done what I did without his assistance. At least, the paintings would have been smaller. It was wonderful serendipity, I suppose.

The great thing is that my office isn't here, it's in LA; they don't get to their desks until it's six o'clock in the evening here. So this is a sort of marvellous bohemian life with a bit of comfort. It's a long time since I've done any ambitious work in London, partly because I don't have too much space there and – more – because there are too many distractions. Here I can paint twenty-four hours a day. Nothing else occupies your mind, other than at your choice. Otherwise, I read a great deal. In London, too, there's always someone dropping in, but not here – it's too awkward a place to get to. I like people to come and stay. I'm not anti-social; I'm just unsocial.

Hockney enumerated some of the beauties of the gently rolling local countryside: no electricity pylons, not many signs, no lines painted on the road in the villages ('they look like official graffiti'), and, above all, no traffic and no people, or hardly any.

It was true that the roads we drove down were almost completely deserted. The Wolds are an empty quarter of Britain, not on the road from anywhere to anywhere. The majority of travellers have always swept past on the Great North Road, now called the A1, an hour's drive or so to the west. This was a return to the scenes of Hockney's youth.

DH I've always loved this part of the world, and I've known it for a long time. In my early teenage years I worked on a farm here on breaks from Bradford Grammar School; it was a place where you could get a job in the holidays. So I came and stooked corn in the early 1950s. I cycled around, and I discovered it was rather beautiful.

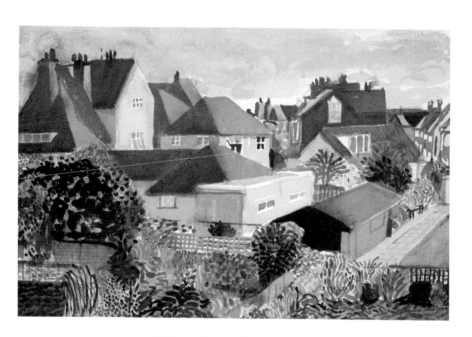

Bridlington. Gardens and Rooftops III, 2004

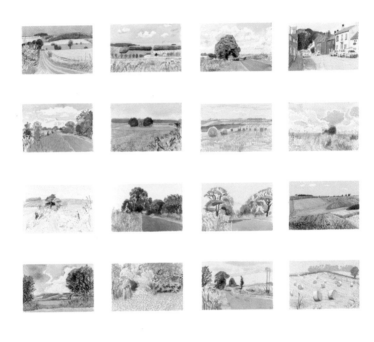

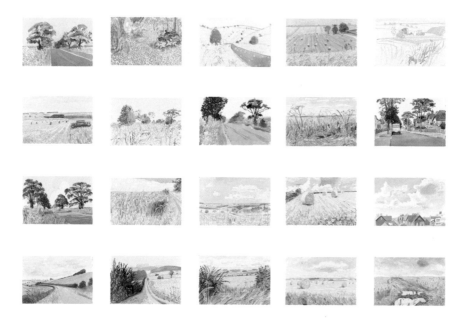

Midsummer: East Yorkshire, 2004

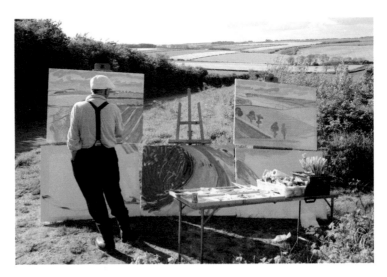

David Hockney painting *The Road to Thwing, Late Spring,* May 2006

Most people don't realize that, because even if you drive
to Bridlington from West Yorkshire you think it consists
of just a few fields. The Wolds are rolling chalk hills.
No one ever comes off the main road. If you do, you're the
only car around. You almost never see another one, just
occasional agricultural vehicles. I can take out large canvases,
never meet anyone. Once in a while a farmer comes to talk
and look. The whole of East Yorkshire is fairly deserted.
Except for Hull, there's no big city. Beverley is the county
town; Bridlington is on the road to nowhere, meaning
you've got to aim to come here. So I can paint here totally
undisturbed. I enjoy this little bit of England very much.

MG But why move now after all those years in California?

DH I'd been coming to Bridlington at Christmas to see my
family for the last twenty-five years. My sister Margaret

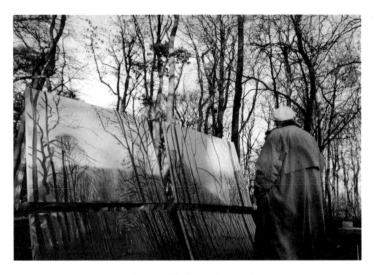

Painting *Woldgate Woods, 4, 5 & 6 December 2006*

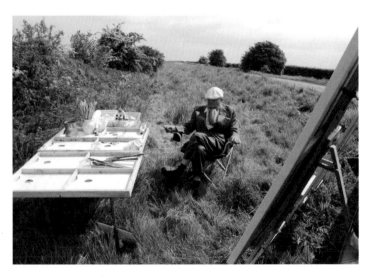

Painting in situ, East Yorkshire, May 2007

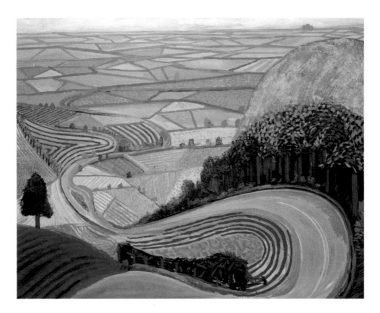

Garrowby Hill, 1998

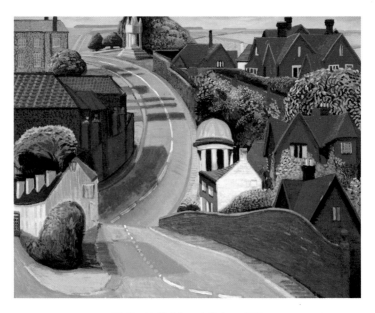

The Road to York through Sledmere, 1997

has lived here for the last thirty years. Even before my mother moved here when she was ninety, she and I would always come from Bradford and spend Christmas with Margaret here. As an unmarried son, I always came for the festivity. I couldn't give an excuse.

MG So why did you begin to paint Yorkshire landscapes in the late 1990s, pictures such as *The Road across the Wolds* and *The Road to York through Sledmere* [both 1997]?

DH When Jonathan Silver, who ran Salt's Mill, the museum of my work at Saltaire near Bradford, got really ill, I came over from LA simply because I could see he was dying. He was a close friend. Before Jonathan's illness we had talked every couple of days on the telephone about art and all manner of things. That was in 1997, and it was the first time I'd stayed in England for a few months since the 1970s. Jonathan lived in Wetherby, which is a very pleasant drive from Bridlington, via York. I was going there every couple of days to visit him, and I started noticing the countryside and how it changed. Because it's agricultural land around here, the surface of the earth itself is constantly being altered. The wheat grows, then it's harvested, then you see it ploughed.

MG So *The Road to York* is about that journey?

DH Yes, but that was in late summer. I never stayed on in Bridlington after Christmas. It was too dark and cold. I always went back to LA, so I never saw spring here. The first one I saw in Britain for twenty years was when Lucian Freud was painting my portrait in 2002 and I used to walk to his studio in Kensington through Holland Park.

MG In Britain, spring can be pretty cold and wet, even if it's not quite so dark as winter.

DH But the rain is a good subject for me. I began to see that that was something you miss in California because you don't really get spring there. If you know the flowers well, you notice a few coming out – but it's not like northern Europe, where the transition from winter and the arrival of spring is a big, dramatic event. The surface of the desert in California doesn't change. Do you remember Walt Disney's *Fantasia*? In the original version, they used Stravinsky's *The Rite of Spring* for one section. But they didn't get what Stravinsky's music was about – they used dinosaurs trampling about. It struck me that the Disney people had been in southern California for too long. They had forgotten northern Europe and Russia, where you go from winter to everything forcing itself up through the earth. *That* is the force in Stravinsky: not dinosaurs pushing down, nature coming up!

MG Did you just decide one day to settle here?

DH It happened more gradually. Originally, I was intending to go back to LA, but I didn't because it was getting more and more interesting in Brid. Eventually, I stayed the whole year, and I saw how beautiful the winter was. But of course then you only get six hours of daylight. In August, we have about fifteen hours. I'm incredibly daylight-conscious, and light-conscious generally. That's why I always wear hats, to minimize dazzle and glare. Here the light might change every two minutes. You have to figure out how to deal with that. In fact, we came to the conclusion that every day was totally different in this part

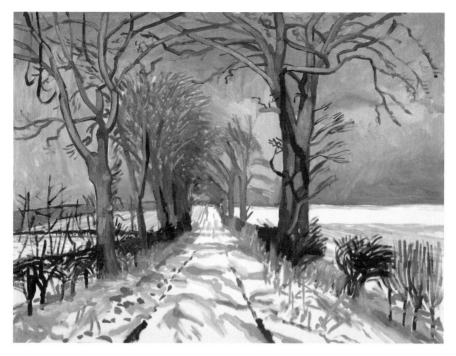

Winter Tunnel with Snow, March, 2006

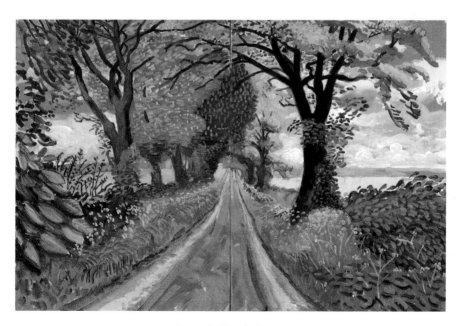

Late Spring Tunnel, May, 2006

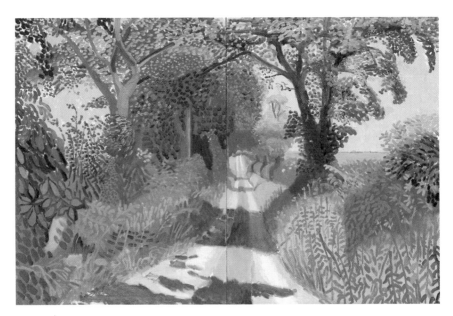

Early July Tunnel, 2006

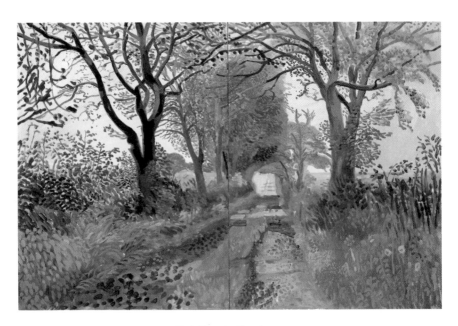

Early November Tunnel, 2006

of East Yorkshire. There is absolutely constant change. Superficially, Bridlington and the country around haven't altered much in fifty years. But when you are here, you can see how it varies continuously. The light will be different; the ground changes colour. In southern California if you went out to paint, the only thing that would be fluctuating are the shadows as they moved. Here the shadows might not be there much of the time, but other things are constantly altering. Somebody came up to visit and said, 'I can see why you like it here David; it hasn't changed much, but it changes all the time.' I said, 'Yes, precisely'.

Hockney was engaged with one of the perennial themes of land-scape painting, music and pastoral poetry: the Four Seasons. The activities of the changing months were a staple of medieval art. They are carved around the doorways of gothic churches, painted in illuminated manuscripts. Pieter Brueghel the Elder and Poussin produced cycles of the Seasons. James Thomson wrote a long poem on the subject, which was a favourite of Constable's. Haydn's oratorio *Die Jahreszeiten* (The Seasons) was based on Thomson's poem.

That first day, Hockney took me to some corners he had been painting, including the place he had dubbed 'The Tunnel': a track leading off the road that is flanked on both sides by trees and bushes arched over the centre, forming a natural, leafy roof. They were all pieces of what could be called – in the manner of a wine merchant who markets 'Good Ordinary Claret' – 'good ordinary English landscape': nothing spectacular, nothing certainly to attract tourists in search of beauty spots. Its attractions, like those of Constable's East Bergholt, were revealed only to those who observed it long and hard. Looking long and hard, it turned out, were two of the essential activities in Hockney's life and art – and also two of his greatest pleasures.

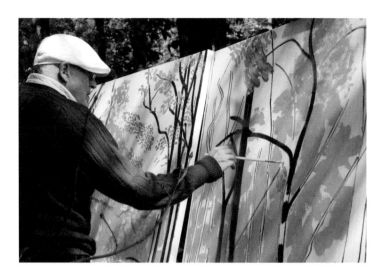

Painting *Woldgate Woods III, 20 & 21 May,* 2006

DH I wanted to paint the whole year, because you see different things as the seasons change. I painted 'The Tunnel' for the first time in August 2005. I named it because it was a tunnel of foliage, with the branches of the trees arching over the path. Then I painted it again several times over the following months. The picture I did in July shows the abundance of nature, compared with the previous ones. Only after seeing the winter, do you comprehend the richness of summer. The second large painting I did after 'The Tunnel' was of Woldgate Woods. When I did it, I didn't plan to do four, but then I understood how I could see the space very clearly in the winter because there is less foliage and the trees go straight up, reaching for light. So I went on and did a series.

MG Trees are the stars of much of your recent work. Why the fascination?

DH Trees are the largest manifestation of the life-force we see. No two trees are the same, like us. We're all a little bit different inside, and look a little bit different outside. You notice that more in the winter than in the summer. They are not that easy to draw, especially with foliage on them. If you are not there at the right time, it is difficult to see the shapes and volumes in them. At midday, you can't do that.

MG Have you become a connoisseur of trees, then?

DH Yes, the trees become friends. One road I like particularly has trees that must have been planted two hundred years ago. I've always liked trees, but being here you look really hard at them. You notice things. The ash trees are always the last to come out.

MG The ash was Constable's favourite tree.

DH They have marvellous shapes. Constable, of course, knew the place he was in intimately. He was very well acquainted with that landscape around East Bergholt; and he did do trees better than Turner. He must have known exactly what time you could see the trees clearest. You can work out approximately at what time of day his oil sketches were painted. The shadows will tell you: if they are long, it's morning or evening. He didn't generally paint the landscape in winter, did he?

MG No. Before he was married in 1816, he would generally leave London to stay with his family in the country in early summer. It's rather touching that every year he writes to his girlfriend, Maria, to say that the foliage is richer and finer than he's ever seen it before …

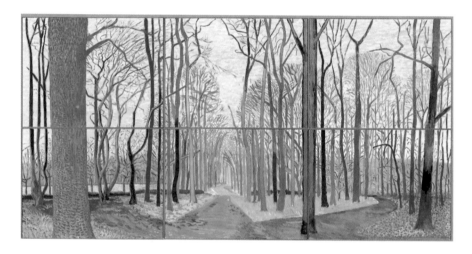

Woldgate Woods, 30 March – 21 April, 2006

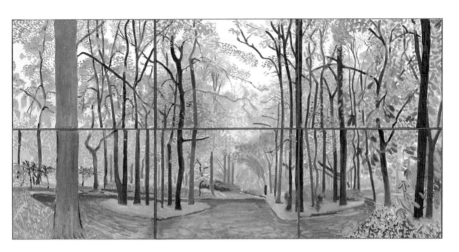

Woldgate Woods III, 20 & 21 May, 2006

DH Because there'd been a winter. Every time we get the
spring I get thrilled like that. Here we've noticed – and it
takes you two or three years to notice – there's a moment
when spring is full. We call it 'nature's erection'. Every
single plant, bud and flower seems to be standing up
straight. Then gravity starts to pull the vegetation down.
It was the second year I noticed that; the third, you notice
even more. At the height of the summer, the trees become
a mass of foliage, and the branches are pulled down by
the weight. When it falls off, they'll start going up again.
This is the sort of thing you notice if you are looking
carefully. The fascination just grew for me here. This was
a big theme, and one I could confidently do: the infinite
variety of nature.

MG That's your real subject isn't it?

DH It is actually. Van Gogh was aware of that, when he said
that he had lost the faith of his fathers, but somehow found
another in the infinity of nature. It's endless. You see more
and more. When we were first here, the hedgerows seemed
a jumble to me. But then I began to draw them in a little
Japanese sketchbook that opened out like a concertina.
J-P was driving, and I'd say 'Stop', and then draw different
kinds of grass. I filled the sketchbook in an hour and a half.
After that, I saw it all more clearly. After I'd drawn the
grasses, I started *seeing* them. Whereas if you'd just
photographed them, you wouldn't be looking as intently
as you do when you are drawing, so it wouldn't affect you
that much.

Bridlington July 14, 2004

2

Drawing

Hockney drew as a child, he once speculated, because he was 'more interested in looking at things than other people'. That is, he wanted to draw because he was fascinated by the visual world. He still is. Indeed, at a pinch, any object or view will do, anything can be enthralling to look at and depict: a foot and a slipper, for example. Of course, Hockney has his characteristic preoccupations as an artist: spacious landscapes, water, wilderness, people he knows, human bodies, plants, dogs, interiors. But in his case, prior to focusing on a specific sight is the fascination he finds in translating just about anything he sees into lines, dots, splodges of colour, brushstrokes – in a word, marks. He believes that is an aspect of being human. 'The urge to draw must be quite deep in us, because children love to do it – being bold with crayon. Sometimes I watch them and I think I must have been like that. Most people lose it, but some of us keep it.'

He was born in Bradford on 9 July 1937. By the age of eleven, he had decided to become an artist, despite not knowing exactly what one did. When he was thirty-nine, he looked back on his early life in an autobiography, *David Hockney by David Hockney*:

> The only art you saw in a town like Bradford was the art of painting posters and signs. This was how one made one's living as an artist, I thought.... Of course I knew there were paintings you saw in books and in galleries, but I thought they were done in the evenings, when the artists had finished painting the signs or the Christmas cards or whatever they made their living from.

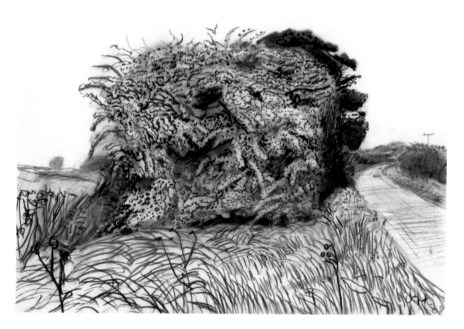

The Big Hawthorn, 2008

Despite this uncertainty, the young Hockney was utterly determined to pursue his career. He won a scholarship to Bradford Grammar School, but was dismayed to discover how little attention was paid there to the subject he loved. 'We had just an hour and a half of art classes a week in the first year; after that you went in for either classics or science or modern languages and you did *not* study art. I thought that was terrible. You could study art only if you were in the bottom form and did a general course. So I said, "Well, I'll be in the general form, if you don't mind." It was quite easy to arrange.'

Hockney's readiness to ignore the academic expectations of Bradford Grammar School was characteristic. He continues to be a person who thinks every question through in his own way, draws his own conclusions, and ignores conventional opinions. Recently, he has displayed as little respect for the views of art historians and the art world as he did then for what his teachers thought. 'When I pointed out that I wanted to do art, they told me, "There's plenty of time for that *later*."' Obviously, he ignored that opinion. At Bradford Grammar School in the late 1940s, the mathematics master had some little cacti on the window-sill of his classroom; consequently, the young Hockney felt there was no need to listen to those lessons. He sat at the back and secretly drew the cacti. Arguably, that's exactly what he's been doing ever since. If the methods by which he makes drawings are sometimes cutting-edge, what he is doing is primordial. Drawing, making a mark on a wall or a clay pot: these are activities that humans have been doing for tens of thousands of years.

MG Perhaps it was playing on paper with pencils, paints, brushes, charcoal – anything – that made you want to become an artist in the first place.

Self-portrait, 1954

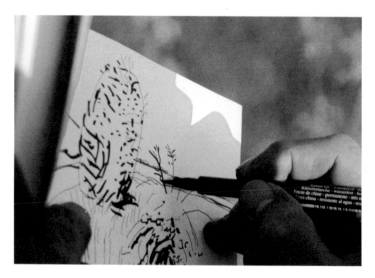

Sketching the hawthorn in situ, May 2007

DH Yes, making marks always appealed to me. I'm still at it. I discovered I loved doing it early on. But don't all children want to grab their crayons and a bit of paper?

MG They don't all become professional artists though.

DH No, but it must be a profound thing. Children usually want to draw something that's in front of them, don't they? 'I'll make you a picture of the house or people, or something.' That suggests it's a deep, deep desire to *depict*.

MG It's an interesting question why it gives human beings pleasure to make and look at pictures. There might be a biological or psychological explanation.

DH Yes, perhaps, but it certainly does give pleasure. I've always assumed that one of my relatives must have been a cave artist who liked making marks on the wall. They'd pick up the chalk and draw a bison running on the wall, and someone else – even without language – would have looked and recognized it, and approved. 'That's just like the animal we're going off to hunt and eat.' So the cave artist would do another one.

MG A real bison, though, would have been frightening. It's an enormous animal.

DH But the picture of it begins to give pleasure. That's why it's hard to represent horrible things in pictures, because by their nature pictures *attract* us.

The oldest surviving pictures are to be found in the caves of Chauvet-Pont-d'Arc in the south of France. According to radio-

carbon dating, these were made up to 32,000 years ago. There has been some dispute about the precise age of the images, but at any rate they can be taken as evidence that the urge to make pictures – and presumably to look at them – goes back a long way (especially if you consider that these paintings are simply the first to survive; others, it is fair to assume, were made before and didn't happen to last). The Dutch historian Johan Huizinga once wrote a book called *Homo Ludens* or *Man the Player* (1938) in which he argued that play was fundamental to human culture. Surely, it would be equally possible to claim that pictures were basic to human life. Not *homo sapiens*, perhaps, but *homo pictor*: the human being as picture-maker.

MG Miró thought art had been decadent since the age of the caveman, since the time of paintings at Altamira.

DH Nobody thinks art progresses, do they? Weren't the fourteenth- and fifteenth-century painters once called the Italian Primitives and the Flemish Primitives? But there's nothing primitive about them actually. They produced very sophisticated pictures.

MG Egyptian art, which some might call 'primitive', also attracted you.

DH Yes it did. I assumed there must have been rules for Egyptian painting because it lasted so long; and for thousands of years artists must have just followed them. So I did a painting in what I called the 'semi-Egyptian style' because I altered some of the rules. That was in 1961, before I went to Egypt. Francis Bacon concluded, I think, that the best art was Egyptian and it has been downhill ever since. You could argue that, I suppose.

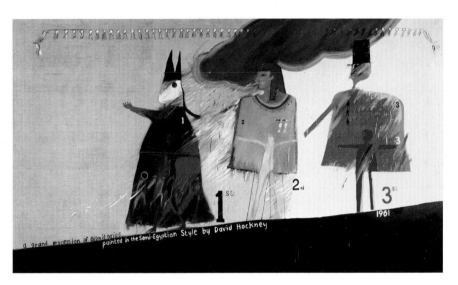

A Grand Procession of Dignitaries in the Semi-Egyptian Style, 1961

3

The trap of naturalism

Hockney's art first came into public view at the celebrated
exhibition 'Young Contemporaries' at the RBA Galleries in
London in 1961. There his work hung beside that of his peers at
the Royal College of Art: Allen Jones, Patrick Caulfield, Derek
Boshier and R. B. Kitaj among them. That show is generally
credited as marking the emergence of British Pop art. But
Hockney, as his longtime dealer John Kasmin once remarked
to me, was a Pop artist 'for about five minutes', if at all. He has
never really belonged to any school or movement. What he had
was an ability to make pictures that were fresh, witty – 'cheeky'
was a word Kasmin used – and full of the mood of the times.
His art was based, from the beginning, on a fundamental techni-
cal ability: Hockney was and has always been a remarkable
draughtsman. In 1994, before I had actually met Hockney
himself, his contemporary at the Royal College of Art and life-
long friend, R. B. Kitaj – now dead – told me an anecdote when
we sat in his house in Chelsea:

> Hockney and I arrived at the Royal College of Art on
> the same day with about eighteen other kids. He made
> that drawing of a skeleton hanging on the wall over
> there. I thought it was the most skilful, most beautiful
> drawing I'd ever seen. I'd been to art school in New
> York and in Vienna, and had quite a lot of experience,
> and I'd never seen such a beautiful drawing. So I said
> to this kid with short black hair and big glasses, 'I'll give
> you five quid for that.' And he looked at me and thought

I was a rich American – as indeed I was: I had $150 dollars a month to support my little family. Afterwards, I kept on buying life drawings from Hockney.

DH What do you depict? That was one of the big questions when I was young. When I began at the Royal College of Art, I'd previously been working in hospitals for two years doing National Service as a pacifist, and I was very keen to get back to art school. But at first I didn't know what to do, so just for something to draw I spent about three weeks making two or three very careful drawings of a skeleton.

The predicament that faced Hockney as an art student in the late 1950s and early 1960s was a perennial one: what to do and how to do it? This was the highpoint of the fashion for American abstract artists, in particular Jackson Pollock and Mark Rothko, also known as the New York School or the Abstract Expressionists. This style was then seen as the next big thing in art, the path of the future. There were several prominent artists in Europe – Francis Bacon and Lucian Freud in Britain, Jean Dubuffet and Alberto Giacometti in Paris – whose work was based in the human figure, but they seemed slightly out of date, throwbacks to an earlier era. The American Willem de Kooning was and usually is grouped with the Abstract Expressionists, but his work was unlike that of the others because there was always at least a tenuous connection with a real sight – a figure, a landscape. De Kooning famously said, 'Content is a glimpse of something, an encounter like a flash. It's very tiny – very tiny, content.' The subject-matter of early Hockney is a bit like that: a dancer at a college party, the Typhoo tea packets his mother sent him (which constituted his five minutes of Pop), a body, a sexual encounter. All of these clinging to life in an abstract visual world of geometric shapes and loose brushmarks.

DH Having been trained at Bradford School of Art rather academically, which I'm now rather glad I was, I wanted to go against that. I was always aware that academic painting then – the kind of portraits at the Royal Academy, for instance – wasn't very interesting really. Most of the lively students at the time were very influenced by Abstract Expressionism. I had a period in my first year at the RCA when I did a few kind of Abstract Expressionist pictures. But I quickly started putting words in them. Instead of a figure, I'd put a word. That came from Cubism, of course.

MG Then, quite soon, actual figures appear, in paintings such as *The Cha-Cha that was Danced in the Early Hours of 24th March 1961*.

DH Yes. Francis Bacon was the first intelligent painter I met who dismissed a lot of abstract art. He quoted Giacometti, who used to say a lot of abstraction was 'the art of the handkerchief' – 'C'est l'art du mouchoir' – covered in stains and dribbles. That was amusing. I was rather impressed that Francis had the confidence to say that kind of thing at that time. Loads of people would have howled him down.

MG That must have sounded outrageous in 1961.

DH He probably liked that in the way I would, just perversely. But I looked not just at Bacon but also at Dubuffet, because his drawing like children's art or graffiti was a way of going against the academic training I'd had.

MG You wanted to paint something real?

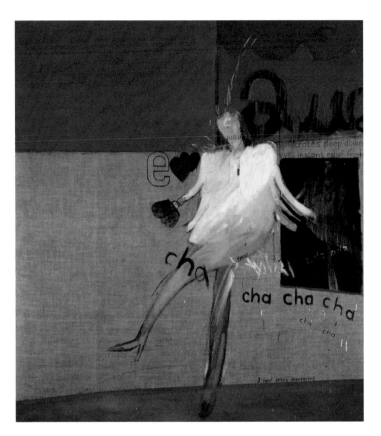

The Cha-Cha that was Danced in the Early Hours of 24th March 1961, 1961

Flight into Italy – Swiss Landscape, 1962

DH I always agreed with Bacon about abstraction, I used to think 'How do you push this?' It can't go anywhere. Even Pollock's painting is a dead end. The American critic Clement Greenberg, who was very influential, announced, 'It's impossible today to paint a face.' But De Kooning's answer – 'That's right, and it's impossible *not* to' – always seemed to me to be wiser. I thought, if what Greenberg was saying was true, all the images of the visible world we'd have would be photographs. That can't be right. It can't be like that, that would be too boring. There must be something wrong with these arguments.

Over the next decade, however, Hockney moved towards a way of painting that he calls naturalism. Several of his best-known and best-loved works – such as *Mr and Mrs Clark and Percy* (1970–1) – are in this manner. He doesn't repudiate those pictures, he remains proud of them. But the paintings of the early 1970s represent an extreme in his work. After a few years, he found it constricting. The sign he had reached the end of that particular path was that he found himself unable to finish a painting, another of his big double portraits: *George Lawson and Wayne Sleep* (unfinished, 1972–5). He also made photographs and drawings for another marvellous picture, *My Parents and Myself*, which he eventually abandoned. From that time on, his work has been concerned with finding ways of depicting the world that escape the trap of naturalism. Another way of putting this would be to say that he has searched for ways of depicting the world that are different from the way a camera lens sees it.

DH Most people feel that the world looks like the photograph. I've always assumed that the photograph is nearly right, but that little bit by which it misses makes it miss by a mile. This is what I grope at.

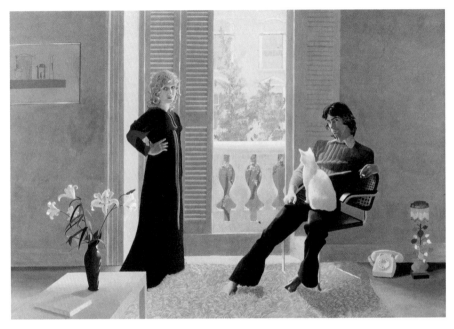

Mr and Mrs Clark and Percy, 1970–1

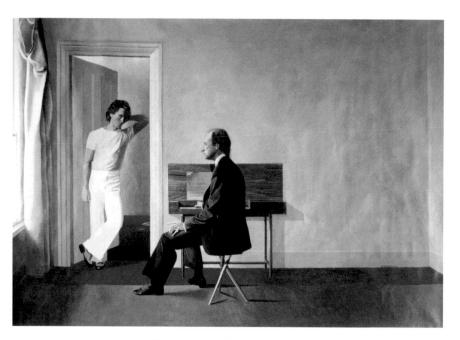

George Lawson and Wayne Sleep, 1972–5

MG But you used photographs yourself as a basis for painting in the late 1960s.

DH Yes, I did, at times. I always knew that you couldn't draw from them very well, because you couldn't see and feel volume in the way you can in life. Of course, there isn't a rule. If you set up a rule about anything, another artist will come along and break it.

MG There are even some pictures you could call 'photorealist', such as *Early Morning, Sainte-Maxime*.

DH There are. But I didn't want to be stuck in the position I'd got into. I went to live in Paris to break it. And when I was living there in the early 70s, I felt very dead-ended. I'd given up some paintings, abandoned them. Actually, I was just drawing at that point. There was something wrong with what I was doing – I've called it 'obsessive naturalism' – but then I didn't know what it was. Photography was causing it; I'd started to take photographs at that point. I wanted to get out. I found that was a trap, and said so. I wanted to stop it.

MG You've been preoccupied with a sort of struggle with photography since the mid-70s, haven't you? You use it in a judo-like way against itself.

DH I suppose I'm interested in images, and photography is how most people see the world – even its colours (although photography can't do colours very well). So I've observed photography for a long time and participated in it myself – but at the same time I've been thinking about what is wrong with it.

Early Morning, Sainte-Maxime, 1968

MG I suppose most people would say that a photograph is just a record of what things look like. But you don't agree.

DH I love Ernst Gombrich's *The Story of Art*; I read it years ago. Recently I read his newer book *A Little History of the World*, and liked that too. But his phrase, 'The Conquest of Reality', which is a chapter heading in *The Story of Art*, was slightly naive. That's insinuating that the European painters conquered the way we look at the world – and that's all there is to it. But I think it's precisely the way we look at the world that's the problem. I believe photography and the camera have deeply affected us. But I think photography's also done us damage.

MG What do you mean?

DH It's made us all see in a rather boring similar way. In 2002, I went to see 'Matisse/Picasso' at Tate Modern with Lucian Freud, Frank Auerbach and John Golding [the curator] at eight o'clock one morning, just us. And it was stunning, a terrific show. When we came out, I noticed there were four big photographs hanging on the wall – recent acquisitions by the Tate. Lucian and Frank just walked past them. I walked up to them because they don't read across the room that well, looked at them and I thought, 'Fuck me, Picasso and Matisse made the world look incredibly exciting; photography makes it look very, very dull. Yet now we're moving back to all the stuff that modernism moved away from.' We live in an age when vast numbers of images are made that do not claim to be art. They claim something much more dubious. They claim to be reality.

MG But why don't photographs represent the truth?

DH We think that the photograph is the ultimate reality, but it isn't because the camera sees geometrically. We don't. We see partly geometrically but also psychologically. If I glance at the picture of Brahms on the wall over there, the moment I do he becomes larger than the door. So measuring the world in a geometrical way is not that true.

MG You mean subjectively and psychologically?

DH Yes. When I'm looking at your face now, it's rather big in my vision because I'm concentrating on you and not on other things. But if I just move for a moment to look over there, your face becomes small. Isn't that what is happening? Isn't the eye part of the mind? If you look at Egyptian pictures, the Pharaoh is three times bigger than anybody else. The archaeologist measures the length of the Pharaoh's mummy and concludes he wasn't any larger than the average citizen. But actually he *was* bigger – in the minds of Egyptians. The Egyptian pictures are truthful in some way, but not geometrically.

MG There are models of the human body made by the blind in which what is important to them becomes more prominent – faces and hands, for example.

DH When Picasso went to see the *Farnese Bull* in Naples, one of the things he noticed was that the hands of the figures are bigger than life, because of what they are doing. And when Picasso himself painted ballet dancers with enormous hands, they look marvellously graceful. There's something light about them. He understood that when the dancer was moving in that way, you follow the hands and therefore, to you, they are bigger.

4

The problems of depiction

The crisis of the mid-1970s was, in retrospect, the big turning-point in Hockney's career. He had enjoyed enormous success very early on, and by the time he was living in Paris, when he was only in his mid-thirties, he was as famous and established as almost any artist alive. His work since then has been remarkably varied. You could say that from not being a Pop artist, he has moved to being an artist with no fixed style at all. Over the past three and a half decades, he has continued at intervals to make relatively naturalistic portraits, still-life pictures and landscapes, but he has also explored Cubism in a highly personal way, and produced a series of designs for opera in a number of diverse, non-naturalistic idioms.

DH I went into the theatre to liven myself up – and then in
1975 I did a painting based on a print by William Hogarth,
which I called *Kerby (After Hogarth) Useful Knowledge.*
That was the first picture I did using reverse perspective.
The point about reverse perspective is that it's more about
you. It means that you move, because you can see both
sides of the object. The Hogarth print – which I discovered
when I was researching before doing the design of *The
Rake's Progress* at Glyndebourne – was a sort of satire
on what could go wrong if you didn't know the rules of
perspective. But for me it was a way of breaking through
my old attitudes about naturalism. After doing that I
worked in the theatre solidly for three years – which was
another liberation, a new kind of space for me – and the

Kerby (After Hogarth) Useful Knowledge, 1975

Walking in the Zen Garden at the Ryoanji Temple, Kyoto, Feb. 1983, 1983

moment I stopped working in the theatre, I started playing about with a camera, when I made the pictures with Polaroids. They answered the question: how do you make a bigger picture out of a mosaic of small images, which are all a Polaroid will produce?

MG There's an irony in the fact that questioning photography led you to become an artist who uses the camera.

DH I thought I should look into this replacement for painting – as it was claimed to be. I began looking at photography from various points of view. They said perspective was built into the camera. But my experiments showed that when you put two or three photographs together, you can alter perspective. The first picture I made where I felt I had done that was in Japan where I photographed *Walking in the Zen Garden at the Ryoanji Temple, Kyoto, Feb. 1983*. I made it into a rectangle by moving around myself and taking shots from differing positions, whereas any other photograph would show it as a triangle.

MG You mean because the lines would recede, in linear perspective.

DH Yes, but of course, the space really is a rectangle. I was very excited when I did that. I felt I had made a photograph without Western perspective. It took me a while. I didn't know much about Chinese art, even when I went to China. The photography I did took me to Chinese scrolls.

MG In fact, your work from the early 1960s has no conventional single-point perspective: it isn't about looking into a box. You just put two things together: a palm tree

and a building, say, and that makes some space between them. Or you put figures against a flat background or in a shallow space, like a stage.

DH A lot of my early paintings are just isometric: that means they have no single vanishing point. I always thought it was better. It was an intuitive feeling, but I was well aware that isometric perspective was Japanese and Chinese. At that time I used to think that Far Eastern pictures were all the same, as you do when you don't know much about something. But I was always interested in their perspective.

MG What about what most people call 'perspective' – that is, linear perspective, which is supposed to have been invented by Filippo Brunelleschi in early fifteenth-century Florence?

DH Linear perspective is a law of optics, so he couldn't have invented it. Boyle didn't invent Boyle's law. He was describing something that was there. A scientific law isn't invented; it's discovered.

MG But for you, is it a scientific law not a law of art?

DH I have said that perhaps the big mistakes of the West were the introductions of the external vanishing point and the internal combustion engine.

MG What's the matter with it?

DH It pushes you away. When I went to the Jacob van Ruisdael exhibition at the Royal Academy some years ago, I thought, 'My God, you're not *in* the landscape at all. It's all over there.'

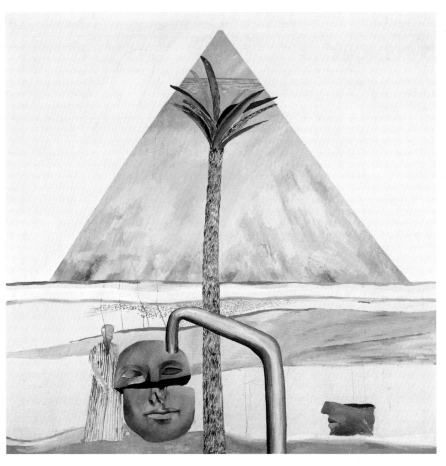

Grand Pyramid at Giza with Broken Head from Thebes, 1963

Play Within a Play, 1963

MG You mean the viewer is automatically outside a picture constructed with single-point perspective? It's made from a fixed point, and so similarly you, the spectator, are fixed?

DH Very, very fixed.

MG So there's no such thing as 'correct' perspective.

DH No there isn't. Of course there isn't.

The crisis of the mid-1970s was resolved, as has happened more than once in Hockney's life, by a change of place as well as a change in the way he worked.

DH I lived in Paris for two years from 1973 to 1975. The Left Bank was still cheap. I worked in one big room, with two little bedrooms off it. I liked it because I could walk into a café and there were always people you knew, and the great thing was that if you got fed up with it you could just get up and go. I like people, but because I lived in the centre, people started coming round to see me; and when they arrived at 3.30 in the afternoon and were still there at midnight, I realized that I couldn't work there. I decided to leave one day, packed up the next.

Hockney is, as this story suggests, both gregarious and solitary. He is a natural communicator, a ready and charming talker. This is one of the reasons, in addition to the power and accessibility of his work, why he has lived from quite early in his career in the public eye. By the late 1960s he was a star, and famous far beyond the art world. He had achieved a dubious position, which he once described as 'the curse of popularity'. To function as an artist, he needed time and quiet; space in which to think and

draw. His solution has been to create a small community around him. Some painters are completely alone. You go to their studios, and there is no one else there, just artist and work. But Hockney operates more in the manner of a Renaissance or Baroque master with assistants. Habitually, he talks as much of 'we' as 'I': 'we saw', or 'we decided', or 'we found' something. But geographically he has tended to isolation.

For a long time, two decades, Los Angeles was his main residence. LA, of course, is not everyone's idea of solitude. It was a good place, however, for Hockney to fade into the background. An English art star was a relatively dim figure in the proximity of so many movie stars. But in the late 1990s, he began to spend less time in California. Slowly, he became more visible in London. The reasons were partly personal. 'One reason I left LA was that a very, very close friend of mine died, meaning someone I saw every day. When he died, I felt the loss greatly. So I suddenly said, "I'm going to London." I found myself staying longer in Britain, and found myself watercolouring in London.' Intuitively, Hockney was no doubt searching once more for something new, a new place, a new way of working. In 2003, he exhibited a series of watercolour portraits, many of English friends, a somewhat challenging project, since that medium – which becomes muddy and opaque if the artist applies more than two or three layers of washes – makes the kind of observation and revision that is normal in portraiture very difficult.

DH I used watercolour because I wanted a flow from my hand, partly because of what I had learned of the Chinese attitude to painting. They say you need three things for paintings: the hand, the eye, and the heart. Two won't do. A good eye and heart is not enough; neither is a good hand and eye. I thought that was very, very good. So I took up watercolour, which I had not used much before.

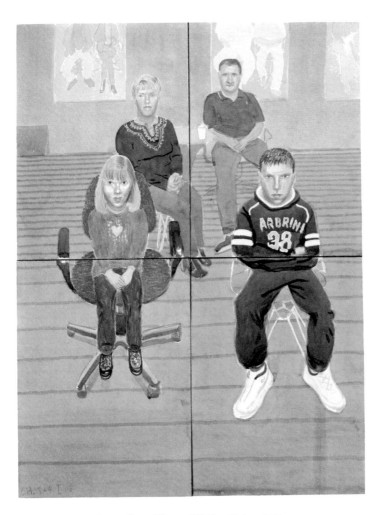

Lauren, Dawn, Simon and Matthew Hockney, 2003

5

*A bigger
and bigger picture*

The next time I made the journey to Bridlington was on Good Friday, 6 April 2007. This time, when I changed trains at Doncaster I found I was not alone. In a little two-coach train bound for Scarborough, I found a deputation from the art world: Norman Rosenthal of the Royal Academy, his wife, Manuela Beatriz Mena Marques of the Prado, and their two daughters, plus Hockney's London dealer David Juda and his wife. We were all en route to see Hockney's latest work, which was apparently huge and intended for the end wall of the grandest gallery in the Royal Academy at Burlington House during that year's Summer Exhibition. Hockney and Jean-Pierre met us at Bridlington station, J-P looking exhausted and the painter himself, exhilarated. Both had grown beards; Hockney, thus untypically hirsute and wearing a hat, slightly resembled Cézanne.

The painting, far too big to go on show in Hockney's studio in the attic of his house, was on display for a few days in a warehouse on an industrial estate near the Bridlington bypass. Sharing the nondescript space with this colossal work of art was a couple of parked cars. A sheepdog belonging to one of the local friends and relations who had come to take a look wandered around giving the scene a distinctly rural touch.

The painting covered almost the entire end wall. It was made up of fifty smaller canvases, adding up to an area forty feet wide by fifteen high. The subject was again what you might call ordinary English countryside: a small copse of trees, with

another in the background behind it, and one larger sycamore in front spreading its network of branches above your head. To the right was a house; to the left, a road curved away. In the foreground a few daffodils bloomed. Standing close to it was very much like standing in front of a real tree. The difference between an average-sized painting and one on this scale was not just a matter of dimensions: you *look into* a normal easel painting; you *stand before* an image as vast as this, looking up.

The picture had elements of traditional perspective construction – there was a building on one side, a road winding away on the other – but it was really the structure of the trees that made the space in it. It was mainly composed of a network of bare twigs and branches, arching above you on either side. It was complex in the way that the pattern of the blood vessels of a human body is complex: an organic system not easily reducible to the straight lines and sharp angles of Euclidean geometry. Gazing up into it, you got lost in the multiplicity of it, but the sensation was a pleasant one. This was an equivalent to the phrase Hockney had become fond of: 'the infinity of nature'. And you, the viewer, were in the middle of it.

DH It's not an illusory thing. It's not a painting that makes you think, 'I want to step into it.' Your mind already *is* in it. The picture *engulfs* you. That's how I hope people will experience it. It is an enormous painting. There are not many paintings this big.

MG Big as it is, close up, you can see that the painting was made up of quick, free, calligraphic brushstrokes.

DH I had in my head a kind of anti-photographic thing, but also Chinese painting, late Picasso – meaning the marks are all visible and boldly made with the arm.

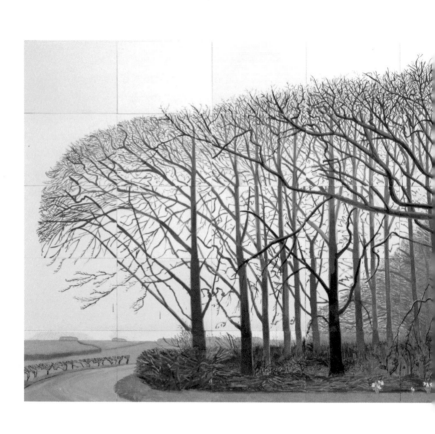

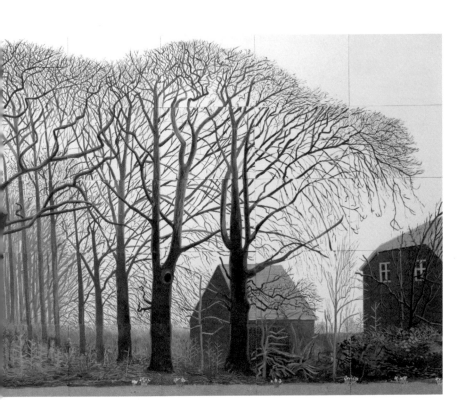

Bigger Trees Near Warter or/ou Peinture sur le motif pour le Nouvel Age Post-Photographique, 2007

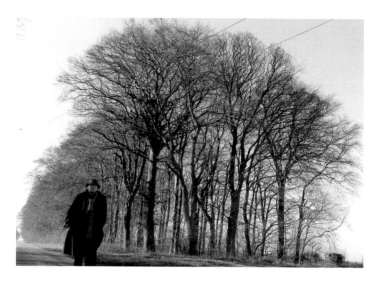

The trees near Warter, February 2008

Sketching in situ, March 2008

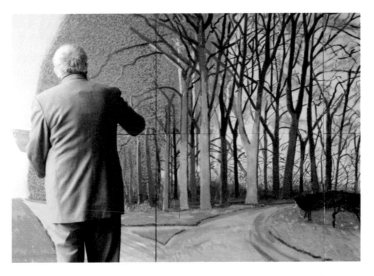

Painting *Bigger Trees Nearer Warter, Winter 2008*, an early six-panel version of the scene

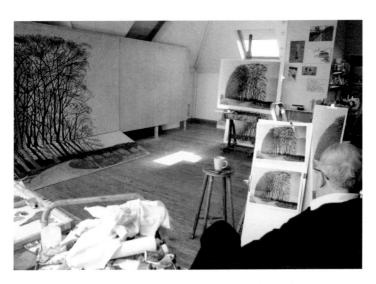

A moment of reflection in the Bridlington attic studio, March 2008

The viewers standing in front would intuitively empathize with it. I'm very aware that the photograph can't do anything like it; a photograph couldn't show you space in this way. Photographs see surfaces, not space, which is more mysterious even than surfaces. I think in the final picture you have a sense of *being there*.

MG How did it begin?

DH I'd already done quite a few paintings made up of six canvases. After I'd finished, we reproduced them – there were nine of them – in three rows of three. I hung them by my bed in Los Angeles, and I saw that there were images of fifty-four canvases up there. Then it came to me that it was possible to make a picture that size in the same way that we'd done the other smaller ones: using digital photography to help you see what you are doing. Then, I thought, 'My God! It would be an enormous painting, but it would be good on the end wall of the big gallery at Burlington House. That grand room – you could use it. Why not? I'd found a way to do an eye-catching landscape for the Summer Exhibition. It was quite a challenge, but I realized that the computer would help here. So I asked the RA if I could I have that wall. And they said yes.

I'd previously done three paintings of the subject in January. When we arrived back from LA, for the first two days I'd go and sit there for three hours at a time just looking at the branches, lying down practically so I looked up. Then I began drawings, which weren't detailed, because I didn't want to make a drawing that I just then blew up. They were to guide me about where each canvas was in the composition. The painting had essentially to be done in one go – meaning, once you started, you had

to carry on until you had finished it. It needed a hell of a lot of planning, but we did it rather quickly. The deadline wasn't the Summer Exhibition. The deadline was the arrival of spring, which changes things. The motif is one thing in winter, but in summer it's one solid mass of foliage – so you can't see inside, and it's not as interesting to me. I loved the winter trees, and think they are fantastic. The problem about painting them is that you don't get that much light at that time. In December and January, you are lucky if you get six hours a day here.

A good deal of the history of landscape painting, up to and including Hockney, is concerned with the question of where to do it – indoors or outdoors? Unlike most of the subjects of painting – the human face and body, still life, interiors – landscape, self-evidently, cannot be looked at in the comfort and convenience of the studio. The only exception is the view that can be seen through a window. From the seventeenth century, if not before, painters have been working outdoors, in the middle of their subject: nature. Certainly this was common practice in the later eighteenth century, and for early nineteenth-century landscape painters such as Jean-Baptiste-Camille Corot. But it was a method for producing sketches or small pictures. The large works that were normally shown in exhibitions at the Paris Salon and at London's Royal Academy were too big to transport outside. The practical difficulties of working out of doors on that scale were just too great. Nonetheless, executing a really large painting *en plein air* was a project that gripped several nineteenth-century artists, John Constable and Claude Monet among them (the latter claimed that he had had a trench dug, into which his *Femmes au jardin*, or *Women in the Garden*, of around 1866 was raised and lowered so that he could work on different parts of the canvas).

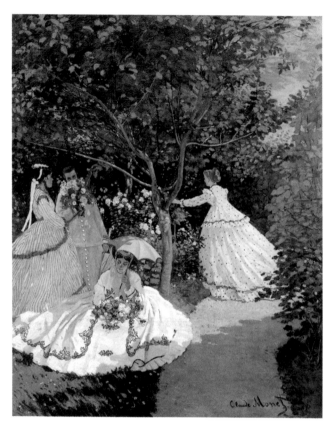

Claude Monet, *Femmes au jardin, c.* 1866

Simply transporting wet oil paintings was a logistical
headache. Hockney's usual procedure when working outdoors
in the landscape is to load up a pick-up truck with paints and
materials, and drive to the spot where he is working. This
required more planning that it sounds. Among other necessary
preparations, a special rack had to be constructed capable of
storing fifty canvases. But the most crucial difficulty of painting
a huge picture outside in the landscape for Hockney – as it was

for Claude Monet – was the difficulty of stepping back so as to relate what he was doing in one part of the work to the rest. Computer technology and digital photography provided a solution. He worked on one canvas panel at a time, with J-P photographing and printing everything as he did it, so he could always compare what he was doing at any moment with what he had done before.

DH I used the aspects of the computer that permit almost instant reproduction, digital photography in other words. That enables you to build up the rectangles and see them together, so I can see immediately what's happening in the picture. Technology is allowing us to do all kinds of things today, but I don't think anybody has thought that it could help painting. The computer is a very good tool, but it needs imagination to use it well. It wouldn't have been possible to paint this picture without it. All you could do would be to blow up a drawing.

MG You'd lose that *en plein air* feeling, I suppose.

DH Yes, as you painted, you wouldn't be reacting to what's in front of you.

Bigger Trees Near Warter, as the painting was later entitled, was perhaps the largest pure landscape painting in art history, certainly the most sizable ever painted entirely out of doors. As such, it offers a novel kind of visual experience. After the end of the Summer Exhibition, Hockney briefly turned the gallery where it hung into a kind of installation. High-quality, full-scale photographic reproductions deceptively like the original hung on the other walls, creating a complete environment. You were surrounded by the trees, in the middle of a painted wood.

David Hockney and friends looking at *Bigger Trees Near Warter or/ou Peinture sur le motif pour le Nouvel Age Post-Photographique*, at the Royal Academy of Arts, London, 2007 Summer Exhibition

6

Scale: a bigger studio

That rented warehouse on the Bridlington industrial estate – a place quite as bleak and anonymous as those words suggest – had given Hockney an idea. Early in the following year, 2008, he moved into a new studio on that same estate, an old factory building far larger than the one where *Bigger Trees Near Warter* had been displayed. We spoke about it early March, soon after he'd moved in.

DH I've just rented a very, very large warehouse in Bridlington – the largest studio I've ever had. When I signed the lease for five years, I felt twenty years younger. I stopped feeling frail and started feeling energetic. Occasionally, I collapse and spend three days in bed, which is generally three days asleep because I can't just lie in bed doing nothing. I'm looking forward to painting there because I think it will make a difference to the work and to me being in a bigger space.

Artists' studios are all different. Some are tiny, some large; some are cluttered, some neat. Hockney's old studio in the attic of the house near Bridlington's seafront was fairly compact but strikingly ordered – as are his small studio in London and much bigger ones in Los Angeles. Some painters – notably Leon Kossoff, Frank Auerbach, Lucian Freud and the late Francis Bacon – prefer to work in a sort of cave of paint: a smallish room spattered and encrusted with the stuff. In contrast, Hockney's workplaces are characterized by clean brushes arranged in pots,

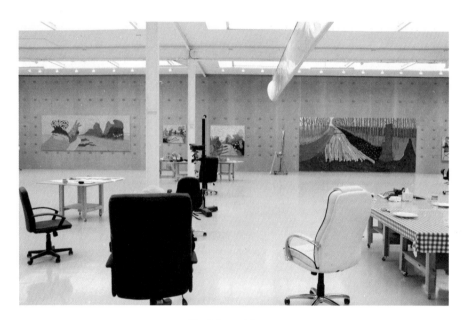

The Atelier, 29 July 2009

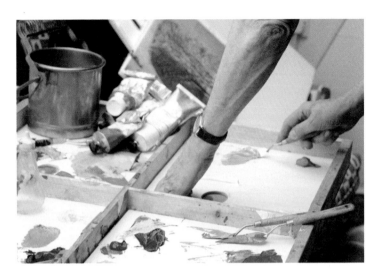

The artist mixing colours in the Bridlington studio, March 2008

pigments set out in wide porcelain dishes, and on the floor scarcely a splodge of stray colour anywhere. All of that tells one something about his approach to painting: that the thick, gooey substantiality of the oil medium is not so important to him as it is to those other artists. Thick impasto is not part of his style – or styles – but bold sweeping marks and heightened colour often are. Consequently, the colours laid out in Hockney's palettes tend to be clear and strong, and some at least of his brushes are amazingly long. 'You can make them with broom-handles', Hockney explains, but his have been supplied by XL brush manufacturers.

This new studio is like the others in those respects, calm and orderly. But it is also startlingly *huge*. Indeed, it is the biggest painter's studio I have ever seen (sculptors' studios, where work is done on a light industrial basis, are another matter). This is more like a film studio: a single enormous white space the size of

a church or theatre, with an upstairs gallery on one side, every inch flooded with an even light coming from the ceiling above. Even on a grey day, walking through the door into it is like stepping into California.

MG Does the place you are working in affect the way you work and what you can produce?

DH It does. It always would anyway, whatever it was like. When we got this studio, it had a profound effect on me very quickly. In the studio upstairs in the house, the paintings were always brighter on the left-hand side than they were on the right because all the light was coming from the window. In this studio, it's bright everywhere, especially during the day. That's why you can take terrific photographs of it. If the windows were on the side, you'd have a very different lighting. A great advantage of the studio is there's a fantastic even light through the space.

The long walls of the studio on the industrial estate could take several whopping pictures at a time. *Bigger Trees Near Warter* would have fitted with ease, and left enough room for another epic scene beside it. But Hockney had a new goal: in 2012, there was to be an exhibition of his landscapes at the Royal Academy. This was now the target to which everything he did was directed.

DH The Royal Academy is offering us these big rooms. Those walls are crying out for great big pictures. They were made for them, and we can do them as well here.

MG So, do you relate the sizes of your pictures to the scale of the place where they're going to be seen?

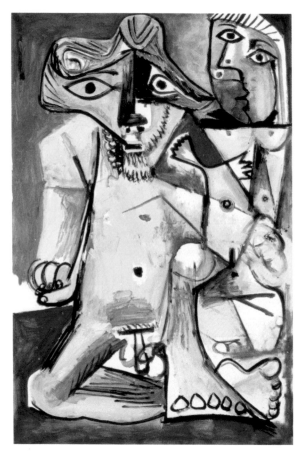

Pablo Picasso, *Nude Man and Woman*, 18 August 1971

DH Well, obviously it makes a difference. When Rothko
 showed his works at the Sidney Janis Gallery in New York
 in the 1950s, they went from floor to ceiling and covered
 half the wall. So if you went there to look at them you
 would have been *dominated* by red. But you aren't in the
 Rothko room at Tate Modern because the gallery there
 is more spacious and taller.

MG But there must be more to it than the fact you've got large galleries available for your exhibition.

DH Perhaps today to make big statements with paintings, you have to paint them big. The size is a bit overwhelming even for me. It's quite a problem drawing on that scale, but I am doing it. I would never have expected to be painting with such ambition at this age. I seem to have more energy than I did a decade ago, when I was sixty. The Chinese are very good on the subject of art. Another saying of theirs I very much like is that painting is an old man's art, meaning that the experience of life and painting and looking at the world accumulates as you get older.

MG Do you believe painters can move into a late style at the end of their lives?

DH Well, a lot of late Picassos are about being an old man, I think. There was a marvellous one we saw in Baden-Baden, a kind of self-portrait as an old man, but it's a baby being led by a woman. His balls are on the floor. His legs are weak. It is a bit like the mother teaching the child to walk. It's the same in old age, somebody needing help. I remember the navel, which was a brushmark that he'd just twisted round. That twist gave it little marks round so that it was softer. It's amazing. You feel the man is old, yet you feel the flesh is soft like a baby's. There are so many layers to it. I suppose you have to be an old man to experience what it is about.

7
Seeing more clearly

John Richardson, Picasso's biographer and a close friend of the artist in his later years, told me a story about Picasso:

> Lucien Clergue, the photographer, knew Picasso incredibly well. The other day he said to me, 'You know, Picasso saved my life.' I said, 'What?' He said, 'Yes, it was after a bullfight, in Arles.' Lucien said he had been feeling fine, had lost a bit of weight but wasn't worried. Out of the blue Picasso said to him, 'You go instantly to a hospital.' Lucien asked 'Why?' Picasso said 'You've got something seriously wrong with you.' Lucien was damned if he was going to do it, but Jacqueline [Picasso's wife] added, 'When Pablo says that, for God's sake go.' So he went, and the doctors had him taken straight into the operating theatre. They said he had an extremely rare type of peritonitis, which is lethal. The bad thing about it is that it doesn't manifest itself in pain, it just kills you. Picasso used to say quite often, 'I'm a prophet.'

I repeated this to Hockney, who strongly agreed with that conclusion.

DH Picasso *was* a prophet. He must have seen something, most likely in Clergue's face. Picasso must have looked at more faces then almost anybody, and he didn't look at them like a photographer. He would have been thinking how would

Artist and Model, 1973–4

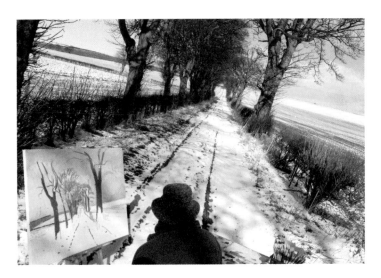

Painting *Winter Tunnel with Snow, March,* 2006

you draw it? Most people don't look at a face too long; they tend to look away. But you do if you are painting a portrait. Rembrandt put more in the face than anyone before or since, because he saw more. That was the eye – and the heart.

MG One of the basic motivations you keep coming back to is that you positively *enjoy* the act of seeing.

DH Oh yes! Just a little bit more … I was driving someone up here and I asked them what colour was the road. They didn't answer. Ten minutes later, I asked the same question, and they saw it was different. Later he said, 'I'd never thought what colour the road was.' Frankly, unless you're asked the question, it's just road colour. You have to look and ask questions like that about what you are seeing all the time. Drawing makes you see things clearer,

and clearer, and clearer still. The image is passing through you in a physiological way, into your brain, into your memory – where it stays – it's transmitted by your hands.

There was a fantastic Monet exhibition at the Art Institute of Chicago in 1995. They got a million people to see it. There are forty-six Monets in the Art Institute's collection, which they lend to other exhibitions, so a lot of museums owed them a favour. As a result, for this exhibition they had got together about a hundred and fifty of his paintings. I went to see it one Sunday morning. It was fabulous. When I came out, I started looking at the bushes on Michigan Avenue with a little more care, because Monet had looked at his surroundings with such attention. He made you see more. Van Gogh does that for you too. He makes you see the world around just a little more intensely. And you enjoy seeing it like that, or I do.

MG So, as you understand it, one of the purposes of visual art is to make you look – to fix your attention.

DH I love that about it. Pictures influence pictures, but pictures also make us see things that we might not otherwise see.

MG I suppose biologically the point of sight is strictly practical: it enables you to spot things you might eat, avoid creatures that might eat you. But art is to do with something else: impractical observation for its own sake – for enjoyment.

DH I've always had intense pleasure from looking. When I was young, as soon as I was old enough to go on buses on my own, I used to go straight upstairs, where it was blue with smoke in those days – I survived – and would go right to

the front of the bus so I could see more. In a car, I always want to sit in the front for the same reason, because it is such a *pleasure*. Early on, I realized that not everybody gets that. Indeed, I've come to think that most people just scan the ground in front of them. As long as that's clear and they can move forward, they don't bother about anything more. Looking is a very positive act. You have to do it deliberately. Hearing is the same. If you concentrate on music, you're going to hear more. Well, you do if it's reasonably complicated, if there are things to hear in it. That's why, for example, Léo Delibes's ballet music is lovely but you wouldn't want to hear it that often, because you get it too easily. It's not quite complicated enough.

MG Talking of visual pleasure, van Gogh and Gauguin were interested in a pleasure that was almost sexual. Writing about the joy of seeing, van Gogh uses a word that also means 'orgasm' in French.

DH I was looking the other day at a video game. It's one of those where you're forever killing people. I watched it for a while, then I decided that it was not at all like any real-life situation of that kind would be. In reality, if you thought there were enemies around with guns, your eyes would be very intensely active, looking for any movement. Your peripheral vision would be incredibly sharp. GIs in Vietnam talked about 'eye-fucks'. They were aware that when they were on the move they had to keep their eyes intensely looking for a tiny quiver in a little leaf over there or over there, taking in as much as they could. It might have been the only time in their lives when they looked with that intensity. I loved the term 'eye-fuck': it's a way of saying the eye is having an extreme enjoyment.

London July 15th 2002

Hockney is person of voracious intellectual curiosity. It is quite hard to mention a book about history or ideas that he has not read – or is not just about to read. But even when reading novels or poems, a lot of his pleasure seems to be visual. He tells a story about his early exploration of literature.

DH I read Proust a long time ago, and I probably didn't get too much from it. I can remember having to look up asparagus – this was in Bradford in 1959; I'd never come across it. But the other thing I always remember was how marvellously visual some of his passages are. There are two or three pages that stuck in my mind that are just about the waft of a curtain. The way it is slightly swaying, the slight swaying suggesting a wave from the sea. The description goes on and on, and this tiny little thing becomes so vivid.

That's just the kind of little detail of experience that might appear in a Hockney drawing, particularly the sort he began to do on his iPhone.

8

Drawing on a telephone and in a computer

As I turned into Dering Street from Oxford Street, I saw Hockney standing on the pavement having a cigarette. He was dressed for this bright spring day in a grey suit and red tie. It was precisely 3.30pm on 21 April 2009, the time we had arranged to meet to see an exhibition of new prints he had made, at his London gallery, Annely Juda. Before we started to look, he removed a little gadget from his pocket: an iPhone. Personally, I am not an early adopter of new technology, and this was only the second I'd seen. A friend had shown me hers, which could be made to contain a pond of virtual goldfish, responsive to the touch. Hockney too had the goldfish app, but also a virtual electric razor with which he gave himself an enthusiastic shave '*Brrrrzzzzt*', and then drank a digital glass of beer, another app, the level of which slowly glugged down in his phone. Plainly, he was delighted with this new toy. But the aspect that interested him most was not the virtual razor or lager, but the fact that here in his hand was a brand-new medium for art.

DH I hardly make telephone calls on it. I send texts, partly because I'm going deaf. And I draw flowers every day and send them to friends, so they get fresh flowers every morning. And my flowers last. Not only can I draw them as if in a sketchbook, I can also send them to fifteen or twenty people who then get them immediately. So they wake up and say: 'Let's see what David's sent us.'

The example he showed me – lilac roses in a vase – looked ravishing. After that, we got on with looking at the exhibition. At the end, we exchanged mobile telephone numbers, something we had not done before. From that point, my communications with Hockney often took place through his preferred medium: the text. A month later, I had my own iPhone – a birthday present, prompted by me, partly because of that demonstration (though I have not been tempted by any of those jokey apps).

On the second weekend in May, my wife Josephine and I were visiting Yorkshire for a dinner, lecture and exhibition opening at Shandy Hall in Coxwold and stayed overnight. The next day we drove over for lunch at Bridlington, an invitation that had been issued by text. There was, however, a potential hitch: 'If the hawthorn is out, I will be drawing or painting. I'm just going out to check on things. I will send you a report later.' This duly arrived: 'I think the hawthorn will be another week round here.'

As a result, we were exceptionally hawthorn-conscious as we drove north. From Cambridge, where we live, all the way up the A1 to Scotch Corner it was in blossom; farther south, there were billowing drifts of it beside the road. As we drove east to Bridlington, however, as predicted it grew patchy then petered out. Hockney opened the door of his house wearing an elegant pin-striped suit, decorated with an occasional paint-stain and accompanied by a couple of frisky, barking dogs. He gave us a demonstration of his new technique of drawing on a computer: Hockney sitting poised and tense like a runner on the blocks, ready to race, while J-P got the program up and running. Then we had lunch in the studio, fish and chips fetched by J-P, who added a tub of mushy peas – a touch of authenticity from a French student of English provincial cuisine. The iPhone seemed as obligatory an accessory for the Hockney *équipe* as a packet of cigarettes; J-P had one too, on which he took our

photograph. Seeing I was a member of the club, Hockney said he would send his little drawings to my iPhone too. And from that point, they began to appear in amazing abundance. Sometimes several arrived in a day. It was a tremendous creative spurt, which went on at the same time as he was at work on a series of ambitious paintings.

They were fresh, delicate, inventive. In contrast with epic paintings such as *Bigger Trees Near Warter*, these were miniatures: smaller than a postcard, seen from a foot or two away. Some were scratchily linear, using thin, wiry lines; some were soft focus like watercolour paintings or gouache. You could watch him systematically working through the possibilities of this new kit, containing not only colours and tones but also a range of virtual lines and washes. What Hockney drew on his iPhone was more or less what he had always drawn: little landscapes, flowers, interiors. In other words, what was in front of him – just like the cacti on the mathematics teacher's desk at Bradford Grammar School. Indeed, one of the earlier iPhone drawings to arrive was precisely that: a picture of a little cactus in a flower-pot. A lot of them were of flowers. Hockney's partner, John, would buy a different bouquet every day and often Hockney would sketch them: roses, lilies. Another regular subject was sunrise over the beach. This became ever more insistent as a subject as the year moved towards midsummer and the sun climbed in the sky. Towards the end of June, we had a long talk about it on the telephone:

DH I must admit that the iPhone took me quite a while to
master, to discover how to get thicker and thinner lines,
transparency and soft edges. I didn't begin drawing
on it until last January. But then I realized that it had
marvellous advantages; it is a stunning visual tool.

Untitled, 2 June 2009, No. 2, iPhone drawing

Untitled, 13 June 2009, No. 3, iPhone drawing

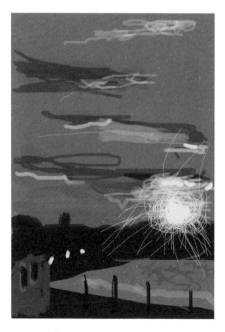

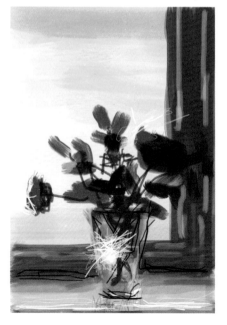

Untitled, 19 June 2009, No. 4, iPhone drawing

Untitled, 8 June 2009, No. 2, iPhone drawing

Untitled, 2 June 2009, No. 3, iPhone drawing

MG How do you actually draw on the screen? It's very small.

DH I'm drawing them mostly with my thumb. You can't draw them with your thumbnail because I think it reacts slightly to heat. I use some collage techniques; finally I got rather good with it. It takes a while to do that, but I'm willing to spend some time. It takes three months? Fine, let's have a go. At my age, it's exciting.

MG Is it influencing the way you draw? It looks as if it is.

DH The iPhone makes you bold, and I thought that was very good. I've looked at them blown up on a big screen, and they made me very excited because you didn't have any loss of colour, and instead of the finger doing it, it looked as if you were doing it with your arm swinging round. I thought, 'Hmm, this will affect my painting, trying to find the minimum number of marks needed to do something.'

Art sometimes emits light. Gainsborough made some little landscapes on glass in the late eighteenth century, intended to be seen in an illuminated magic lantern. Louis Daguerre, the inventor of one of the early photographic processes, the daguerreotype, also devised a novel visual spectacle he called the diorama, in which natural dramas such as fires, sunsets and volcanic eruptions were displayed by shining lights through large translucent paintings. The diorama was an ancestor of the cinema. Medieval stained glass and Byzantine mosaics were further examples of art that was, in one way or another, an emitter of light – the former because the sun shone through it, the latter because illumination was reflected from it.

The iPhone, however, in contrast, is intimate – held in the palm of an artist's hand, the mark made with the hand itself.

This was digital sketching, free and wonderfully immediate. Perhaps because they come via a telephone, the pictures seem like a means of visual communication, a sort of drawn diary – a little like the one Constable made for Maria Bicknell in 1813, consisting of sketches of trees and cows in fields. Looking at the daily iPhone drawings told you something about where Hockney was, what he was doing and how he was feeling.

DH The other day I thought maybe I'd put some canvases by the bed and do some little paintings here. But as soon as first light came up I realized how dark it was in the room. You could hardly see the paint, but with the iPhone, because it's illuminated you can draw in the dark. In fact, you can't see it that well in a bright light, though you can in a dark place. The light itself is the subject of a lot of them – the light coming through shutters, the bright window. I'm doing a lot of the drawings of the dawn and vases of flowers in bed, because I've got this lovely window, and the flowers are there and the light's changing. At this time of year the sun is on my side of the house. I wake when it starts getting light; I leave the curtains open. The sun rises now about 4.20am, and it's light a good hour before that. If there are some clouds about, you get drama – the red clouds, the light underneath.

New technology acts on Hockney as a stimulant. It had happened before, and was to happen again, twice in two years. Not many people would think of the iPhone as a means of drawing. But it was not the first time he had adapted an improbable new medium. During the 1980s, he used the photocopier and then the fax machine – which, one might have thought, were devices better suited to an office than an artist's studio. Hockney, however, seized on both and used them to make prints.

Breakfast with Stanley in Malibu, Aug 23 1989, 1989

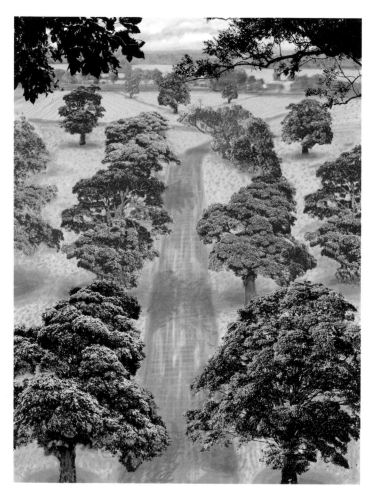

Summer Road near Kilham, 2008

Later he tried drawing on the first computer systems that allowed you to do so – with mixed results, since he found there was a long and distracting delay between his drawing a line and its appearance on the screen. That was in 1987. He experimented again with a Macintosh computer in 1991, and again it was struggle – this time because the colours that he saw on the screen and the ones he printed out were confusingly different.

Now, computer technology was catching up with what he wanted to do – that was also true of the prints in the exhibition I had gone to see that day when he had first showed me his iPhone. These were a positively promiscuous blend of the photographic and the hand-drawn. Some look like painted landscapes; some, like photo-collages; some, like a novel blend of both. One gallery was full of computer-drawn portraits that depicted the Hockney circle at Bridlington: his sister Margaret and brother Paul, both gazing at their iPhones; Jean-Pierre in a dinner jacket; John; a few other friends and associates.

DH They were drawn from life; most took about eight hours. Photoshop is a terrific medium. What you are really doing is drawing in a printing machine. You don't look at your hand, you look at the screen. Then I print it out, see what it's looking like, see what colours you get. So you actually use the colours that the printing machine makes. Using this medium means you miss some things – you miss texture – but you gain a lot. Then I discovered how good it would be for portraits because of the freedom you have to alter things. You can do that amazingly. In a watercolour portrait, once you put things down that's it. With this, you can move things about, change, make them bigger and smaller. The black is like nothing else you can print. It's fantastically dense.

MG Why do you use so many different means and media to make art?

DH Anyone who likes drawing and mark-making would like to explore new media. I'm not a mad technical person, but anything visual appeals to me. Media are about how you make marks, or don't make them. In linocuts, for example, everything has to be bold. You don't make tiny, thin lines in a linocut, it would be too niggily. But get an etching plate, and it's about fine lines. Anybody who draws will enjoy that sort of variety of graphic medium: because it requires *inventiveness*. Rembrandt, like van Gogh, made a great variety of mark. They both had great, great graphic invention.

MG Rembrandt was a printmaker, but van Gogh, with a few exceptions, wasn't. What has made you such a prolific maker of prints in all manner of media? Why the constant experimentation?

DH I've always been interested in printing as a medium, and also as a medium through which my work can be known – can reach a public. So I've taken an interest in any technology to do with image-making: printing, cameras, reproduction itself. Lots of artists aren't interested and don't necessarily have to be. A painter needn't care about any of them; he could still do interesting paintings just with brushes and paints. But I *am* interested.

MG But why choose one rather than another? And why choose one that makes only a limited range of marks, like a fax machine for example?

Paul Hockney I, 2009

DH You might choose a medium because of a certain subject, or do the same subject in different media and see how different they are. Limitations are really good for you. They are a stimulant. If you were told to make a drawing of a tulip using five lines, or one using a hundred, you'd have to be more inventive with the five. After all, drawing in itself is always a limitation. It's black and white, or line or not line, charcoal, pencil, pen. You might have a bit of colour – but if you can use only three colours, you've got to make them look whatever colour you want. What did Picasso say? 'If you haven't got any red, use blue.' Make blue look like red.

9

Painting with memory

DH I'm a happy smoker. I stay in Brid; it's a good place to
watch your money disappear. I think I'm greedy, but
I'm not greedy for money – because that can be a burden
– I'm greedy for an exciting life. I want it to be exciting
all the time, and I get it, actually. On the other hand,
I can find excitement, I admit, in raindrops falling on a
puddle and a lot of people wouldn't. I intend to have it
exciting until the day I fall over.

A few months later, on 14 September, I was back in the
Bridlington studio again. I had travelled north with Edith
Devaney of the Royal Academy, who was working on the big
exhibition planned for 2012, now only a little over two years
away. We had coordinated our visits and were met at York
station by Hockney and J-P, who then drove us down that road,
over the Wolds via the pretty village of Sledmere with an eigh-
teenth-century mansion, that had been the subject of a series of
paintings by Hockney from 1997, his first English landscapes
and the prelude to what he was doing now.

When we arrived, it quickly became apparent that the move
to the new studio had prompted a change in method. The new
paintings we looked at were not painted outdoors, *sur le motif,*
but in the studio from sketches and memory. The new paintings
were more tightly painted, the outlines of the forms sharply
drawn in paint, the colours heightened to strong purples, greens
and oranges. A lot of the pictures were of felled trees – a number
that he had earlier painted on Woldgate had been cut down –

which gave them a strong geometric structure: piles of timber cylinders. 'They chopped down all those trees, now I've got a great new subject. This [pointing at a space in a picture] was a vast number of trees, and suddenly the sky was important, whereas it wasn't before.'

In the newest batch of paintings, instead of painting what was in front of him, Hockney was painting something he had seen some time before. In other words, he was relying on drawings and memory. But memory, of course, is a factor in all human perception – and certainly all painting.

DH We see with memory. My memory is different from yours, so if we are both standing in the same place we're not quite seeing the same thing. Different individuals have different memories, therefore other elements are playing a part. Whether you have been in a place before will affect you, and how well you know it. There's no objective vision ever – *ever*.

There's a story about the French philosopher Henri Bergson. He was sitting in a café opposite Rouen Cathedral, and he said that the only way you can see the cathedral properly from here is to get up, walk right round it, and then come back here. I like that. The point is that you would then have a memory that you were looking at.

Eight years ago, I wouldn't have painted this subject I'm starting now: a clearing filled with grasses. It would have seemed too much of a jumble. I had to keep looking and drawing, and looking. Now, because of all that time I spent drawing these grasses, I know what I'm looking for. How does one overlap another? Where does that shape start and stop? How far up do the nettles go? Of course, even if the subject is in front of you, it's the memory of a second ago, five seconds ago, a minute ago. Each memory

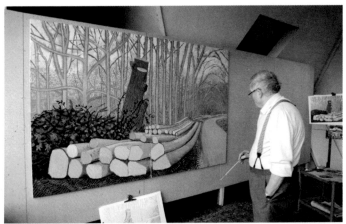

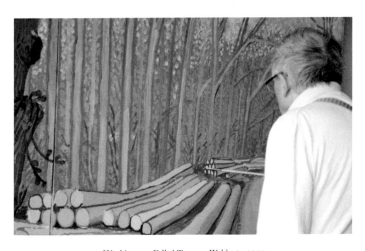

Working on *Felled Trees on Woldgate*, 2008

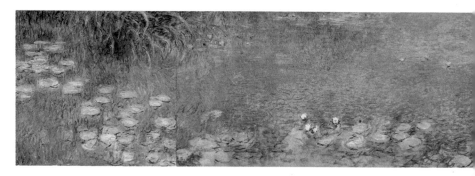

Claude Monet, *Water Lilies: Morning, c.* 1925

will be different in quality, but if you train yourself, if you make notes in your head, you can use them very well.

MG Memorizing sights – and words – is a form of concentration that you can learn. But memory fades quite fast with time.

DH Yes, I think you can train visual memory a bit if you are painting. You decide: I shall go and look at *this* aspect this morning. I'm sure that works if you keep to it, especially if what you are looking at is not far away. Your memory of five minutes ago is incredibly strong.

MG For Monet at Giverny, the subject was his garden, and his studio was next to it – so it was a very short walk between the two.

DH After painting for all those years, he would have systems in his head. I assume he went with a question, and found the answer. If you don't have a question in mind, there's far too much to look at.

MG That's what you do, I imagine?

DH Yes, when I began this painting, I made a few little
drawings. But some mornings I'd just go and stand there
for twenty minutes, and come straight back here. If you
do that you've got an incredible lot in your head. I knew
what I was going to look at. Depending on what you
decide, that's what you see – and you ignore a lot of other
things. So Monet would have decided, I'm just going to
look at *this*. How do you really see the clouds reflected
in the water? Then the memory would be very, very good
for ten or fifteen minutes. Imagine: early in the morning,
all he needed to do was walk down to the lily ponds, have
a few cigarettes sitting there. Then go back and paint.

[A pause]

The best form of living I've ever seen is Monet's –
a modest house at Giverny, but very good kitchen, two
cooks, gardeners, a marvellous studio. What a life! All he
did was look at his lily pond and his garden. That's

fantastic. He was there for forty-three years. He'd seen forty-three springs, forty-three summers had gone, winters and autumns.

A couple of assistants were at work at a table in the middle of acres of studio floor. They were engaged on a long, long picture. It was the successor to a work that had been in the exhibition of computer-drawn prints in London. This looked like a photograph of the side of a road: a sequence of street lamps, hedges, a bus stop, a bit of fence, a few conifers and many deciduous trees of differing types, all leafless because this was a winter picture. At first glance, it looked like a photograph of a very ordinary sort of place, the kind of road that can be found anywhere in Britain, or anywhere in northern Europe for that matter. But looking more closely, I could see that it had one of Hockney's trademark, tongue-in-cheek, what-you-see-is-what-you-get titles: *The Twenty-Five Big Trees Between Bridlington School and Morrison's Supermarket on Bessingby Road, in the Semi-Egyptian Style* (photographed Monday, 23 February 2009). Now the successor pictures – of spring and summer – were under way.

The Twenty-Five Big Trees Between Bridlington School and Morrison's Supermarket on Bessingby Road, in the Semi-Egyptian Style, 2009

DH My sister asked me, 'How did you see that as a subject?' I thought it was a very good question, I answered. 'I'll tell you. I walked past it, and that's what you're doing there.'

MG So it's actually a picture about walking?

DH It's a sort of frieze and it is in the semi-Egyptian style – that is, it doesn't use linear perspective. That's a term I'd used before a long time ago for a picture called *The Grand Procession of Dignitaries in a Semi-Egyptian Style*. That was in 1961, so forty-eight years ago. I couldn't resist using it again. A friend said it's a very long title; I said, it's a very long picture. Each one in the series consists of forty-two photographs put together. But the trees on the road are in that order. They were all photographed separately, then I made the overlaps. That's why it was necessary to draw some of it, to link the images together. I was trying to do a row of trees I love, but you can't see it from one position.

MG They are panoramas of the same place at different seasons, then?

John Constable, *Study of the Trunk of an Elm Tree, c.* 1821

DH No, it's actually not a panorama, because you're an equal distance away from everything. In a panorama you wouldn't be, as that's seen from one central point. This is more of a tracking shot but with a still camera.

MG So, it's a stationary movie?

DH In a way, yes. The photographs took two weeks to draw out after we'd photographed it: two weeks to collage it. That was eye-strain work. Sometimes I'd say, 'I've just got to rest my eyes for an hour,' then we'd carry on.

Trees were the common factor in almost all of Hockney's recent work – the paintings done outdoors, these photo-collages, the paintings done in the new studio from memory. Only the recent computer-drawn portrait prints were an exception, and there was a connection there too, since the tree pictures were also portraits in which each giant plant was an individual: 'like old friends', 'a row of trees that I love'.

This was a feeling with which I could sympathize, since I too had been spending some time thinking about trees. Working on my book about John Constable – which I'd finished in August – had meant I had spent two years in the virtual company of a man, dead for 162 years, who had cared enormously about them. One of Constable's most eloquent pieces of writing was about an ash in Hampstead that he knew and passed by each day. He called it 'this *young* lady', and described its 'destruction' by heartless individuals who had killed it off by driving a nail into its trunk to fasten a notice and lopped off its branches. As a sort of preparation for writing about Constable – to get myself into the landscape mood – I had sat, the summer before, under a spreading lime outside the door of a Tuscan castle and read *The Secret Life of Trees* by Colin Tudge, a book it turned out Hockney had been reading too.

Trees have a dual character. They are, as Constable – and Hockney – hints, like human figures in the landscape, vegetable giants, some heroic, some elegant, some sinister. But they are also, as Tudge explains, remarkable feats of natural engineering, capable of holding up a ton of leaves in summer against the forces of gravity and wind. 'Of course', Tudge writes, 'human architects create structures that are bigger and sometimes, like cathedrals and mosques, are of great beauty. But a cathedral or a mosque is built: it does not grow.... A tree by contrast may grow to be as tall as a church and yet must be fully functional (apart, perhaps, from the business of reproducing) from the

moment it germinates.' As it grows, the tensions and stresses alter, but it must always arrange itself so as to accommodate them. A tree is, indeed, much more complex than human architecture, which explains some of its visual characteristics.

DH Trees don't follow the laws of perspective, or don't seem to, because they are so complicated, with lines going in so many directions. I found when I was doing some collages with photographs of trees I had made, that you could believe that you were looking down on the tree even though I'd photographed it looking up.

MG From a lot of viewpoints, what you see is essentially the same; you are looking through a skein of branches, leaves and twigs. You can understand it from any direction.

DH Trees have a deep appeal, and I think it's partly a spatial thrill, a certain kind of thrill that I'm very conscious of.

Thinking about Constable and talking to Hockney were helping me to understand why they were interesting. Trees are presences in the landscape, but also catchers of space and light. They stand up as markers, dividing up the surface of the land; but they also contain space within them, especially when their branches are bare. Space, as Hockney points out, is difficult to perceive if it has no edges. A bare tree helps you to sense space within the maze of its structure, in a complex way. In leaf, on the other hand, a tree functions more as a container of light. Again, light is not easily perceived unless it falls on something. And much of the time the largest, most complex object visible outdoors will be a tree, or a mass of them – a wood, a forest. Therefore it is often when we look at trees that we actually see the beauty of a certain light.

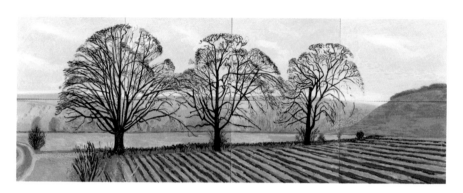

Three Trees Near Thixendale, Winter 2007, 2007

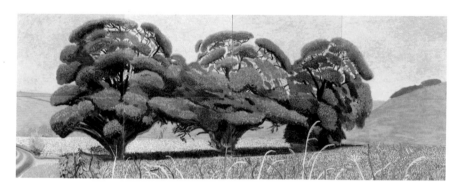

Three Trees Near Thixendale, Summer 2007, 2007

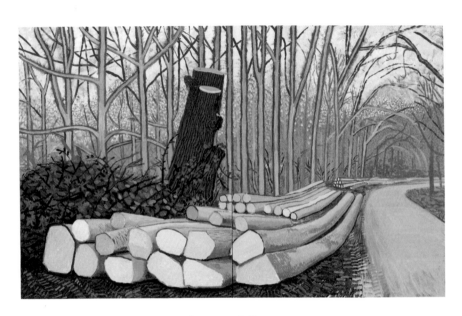

Felled Trees on Woldgate, 2008

After Edith and I had looked at the pictures and had lunch, Hockney drove us across town – past Bessingby Road and its trees – to the house, and there we went upstairs to the viewing room, a miniature private cinema where the Hockney household watches films – a strong interest of his and theirs. This time, however, we weren't there to watch that kind of movie. Hockney, it seemed, had made one of his own – a landscape film shot at the height of the hawthorn in early summer. It had been taken from a moving car in a quiet valley near Sledmere. Technically, it was a bit rough – the camera had been held by Hockney himself and there was some wobble – but it was strangely moving, a slow, slow progression through billowing blossom. Hockney kept up an enthusiastic running commentary: 'There's a beautiful branch here, just waving against the sky. Look at the shadows on that tree!' Was this a new medium he was starting to explore? I asked at the end, 'Is this a work, do you think?' He seemed surprised, and not quite sure of the answer, but said, 'Yes, maybe it is.'

Pearblossom Hwy., 11 – 18th April 1986 (Second Version), 1986

10

Photography and drawing

As these conversations continued, I began to grasp the point of Hockney's insistence on that word 'layers'. A painter is not simply adding more and more paint to a canvas or piece of paper; fresh thoughts and observations are going on, each adjusting the one that came before. The process of writing – reflecting on the subject, editing and adding to what we have written before – is essentially similar. Much human experience, when one comes to think about it, is a matter of layering. We understand the present by comparing it with the past – layer upon layer – then we think about it afterwards, adding more and more layers. As we do, our angle of vision changes.

Those two elements – time and perspective – come into all our images of our experience, all our narratives about it. The more I thought about that, the more I understood Hockney's objections to the photograph, which contains by its nature a mere instant of time, and a single point of view. He was addressing both of those limitations, however, with his stately film of the hawthorn, which seemed to expand time and slowly shift in vantage point. In the 1980s, he had achieved much the same effect with his Polaroid collages – photographic images, yet ones that had been taken not in a fraction of a second but over a matter of hours and from innumerable different positions in space.

MG Your photo-collages, such as *Pearblossom Hwy* (1986), breaks up the single-point perspective view of the world into dozens of different viewpoints – as many as the

number of Polaroid pictures you took. And yet you classified *Pearblossom Hwy* not as a work of photography but as a drawing.

DH You know, the interesting thing is that the only reason the Getty could buy it is that it had to be designated as a photograph. Otherwise they are not allowed to buy twentieth-century art. I said, 'Well OK, but it's also a drawing', because the moment you make a collage of photographs it becomes something like a drawing.

MG Why?

DH Because there is no single way to join them. If you make a decision about something like that, isn't that exactly what you are doing when you are drawing? It seems to me it is. So collage itself is a form of drawing. I always thought it was a great, profound invention of the twentieth century. It's putting one layer of time on another, isn't it? Every serious photographic collection – the V&A, the Metropolitan, the Getty, MoMA – has a group of photographs from about 1860 that show elaborate interiors, with exterior views through windows. You can see gardens and things. Well, you can't photograph the interior and get the outside as well in that way, because of exposure times. In effect, these were made of several negatives – so in a way they are collages. They are not very well known because the photography world dismissed them as not pure photography – they said these are something else. Pure photography is one exposure. I pointed out that what these people in 1860 were doing is exactly the same as what Jeff Wall is doing now. Absolutely the same thing: that is, piecing images together.

Camille Silvy, *Studies on Light: Twilight*, 1859

MG It begins very early in the history of photography. Camille
Silvy was making that kind of photo-collage by combining
several exposures – with a bit of hand drawing – in 1859.
That's a bare twenty years after Daguerre. There used
to be a puritanical view about the purity of photography.
You're interested in all sorts of impure photography.

DH Yes, I am! And even more in painting.

MG But a lot of people – artists included – would say that photography has simply replaced painting and drawing, which are now just archaic survivals.

DH I don't see it that way at all. I was very struck when one of the Turner Prize winners some years ago, Jeremy Deller, remarked that 'Artists don't paint these days, just as we don't go to work on a horse.' I blew that up and pinned it on my studio wall. I thought, he obviously thinks photography has supplanted painting. A lot of people think that. But I know it can't do that. It's not possible. I thought that remark was naive: not understanding what photography was. I don't see it that way at all. Photography is just a blip in a longer history. Now it's coming to an end. We are moving out of what we thought photography was and back to painting.

MG How do you think that is happening?

DH Photography is crumbling. Kodak stopped using the chemical side of photography a while ago, you don't need it – you can do it all with digits. I first found out about Photoshop years ago when I was invited to a seminar in Silicon Valley in 1989. I went with my assistant for a week, and driving back I said, 'Well, this is the end of chemical photography.' A few years later, when I met Annie Leibovitz in California, I asked her whether she was on to digital photography, and she said, 'Well, you have to be now. You have to be now if you work for magazines.' So I said, 'Isn't it nice to be back painting again?' She said, 'I never thought about it like that.' But that's what they're

doing. I look at advertisements and magazines, because they probably show what's going on, more than art photography.

MG You mean because all the images are digitally altered?

DH Yes. Photoshop is intended to polish photographs, and the consequence is those dreary magazines where everybody looks the same. Have you ever seen *Hello* or *OK*? This is what's happened to photography. Everything now is evened out, polished. What's mad about them is that if there are six pictures of six people, they've all got the same expression. If somebody looks at it in twenty years' time, will they know who all these people are? I don't know even now. It will tell them something about our shallow age.

MG They'll look very time-dated, but photographs always do – just like paintings, in fact.

DH Yes, they do because of the technicalities of printing, colour, things like that. I've thought that it could be that the photography itself could date, although to us it seems the ultimate reality.

MG Well, digitally manipulated images are probably going to look very 'early twenty-first century' in the future. You've got a collection of 'badly drawn photographs', incompetently Photoshopped.

DH Yes, you can spot them rather quickly. Being able to draw means being able to put things in believable space; people who don't draw very well can't do that. And so that's what happens most of the time with digitally altered

William-Adolphe Bouguereau, *The Birth of Venus*, 1879

photographs: the space isn't believable. The digits have
altered everything. Nowadays, I don't think you need
believe any kind of photograph from any source. There
is a certain sort of language to photography – but you
can fake it all with computers. Most so-called digital art
is hand-denying, and not that interesting anyway.

MG The histories of painting and photography are deeply intertwined. Perhaps it would be better to think of it as one history – the history of pictures.

DH The history of art is all very comfortable until the invention of photography; but then it becomes rather uncomfortable because nobody knows what the photograph really is. As a result, we then don't include it as part of the pictorial history. But it can't be isolated from it.

MG On the other hand, the painting of the Paris Salon – the kind that the Impressionists and early modernists were reacting against – has a lot in common with photography.

DH Yes. When you think of the academic artists whose work van Gogh knew – such as Ernest Meissonier and William-Adolphe Bouguereau – both were working from camera images. At the time, their work was reaching staggering prices. Vincent quite admired Meissonier, because there is a skill in his paintings. But Bouguereau's figures were wax. They were photographic. Gauguin and van Gogh were looking at the world in a different way. But since then the photograph has dominated. Vincent would not pose for photographs. There are photographs of every other artist from that period, meaning they were prepared to pose for a photographer. But van Gogh wouldn't; he didn't have a high opinion of photography. I assume he didn't think the world looked like that. I agree with him about that, but most people don't. They believe the photograph catches reality. It's catching a bit of it, but not that much of it. That's what van Gogh knew. Van Gogh's – and Cézanne's – is a more human vision of the world, to my mind. When Cézanne referred to Bouguereau as just dishonest, he must

Henri Cartier-Bresson, *Picnic on the Banks of the Marne*, 1938

have meant that we just don't see that way. We see more
like Cézanne's way, doubting the positions of objects.

MG Rodin said, 'It is the artist who is truthful and the
photograph that lies.' But whether or not he or van Gogh
approved, you can't just dismiss photography. It's a
hugely powerful medium, and one you've used yourself.
And some people use it to convey a personal way of
seeing, just as some artists use paint and canvas to do that.
There's a big difference between a good photograph and
a bad photograph.

DH Yes, of course; but is it as big as the difference between
a good painting and a bad painting?

MG Well, for example, Cartier-Bresson took photographs of tremendous power. There's a great gulf between a Cartier-Bresson and an ordinary snap.

DH Agreed. He was the great master of a certain period in photography, without doubt. His pictures are more memorable, maybe, than anyone else's of the mid-twentieth century. Cartier-Bresson must have made eight or ten that are in your mental file, or mine, in most people's mental image bank. *Picnic on the Banks of the Marne* is an example – you can call them to mind. With most photographers, even celebrated ones, there aren't as many images that are as memorable as that – maybe one or two. That means Cartier-Bresson must have seen very clearly. He told me once that the way he composed a picture was a matter of geometry, meaning that he had the ability to look at the world and immediately see it in flat terms as well.

MG The pictures often seem to depend on split-second reflexes. Do you think he was imagining what was just about to happen – to foresee that it was about to make a picture?

DH Yes. But you then think he might have waited until another person came along, because he didn't have a motor in the camera. You never know if his pictures are a bit staged; but if it's a great picture anyway, what does it matter?

The day before I first met him, I'd seen him on the street, taking some photographs. It was on the rue Mazarine in Paris. And I'd seen him do this – moving his camera slightly up and down and from side to side – and I knew what that was. I thought, 'That man knows what he's doing. I'll follow him a bit.' Composing a picture is very much to do with what happens at the edges. The day

after I'd seen him, Claude Bernard said to me, 'I'd like you to meet Henri Cartier-Bresson.' So we were introduced. It turned out he wanted to talk about drawings, and I wanted to talk about photography. He said he was giving up photography, and he did soon after.

MG He spent a lot of his final decades drawing rather than painting; and of course he studied painting before he took up photography. That's true of a number of outstanding photographers. Brassaï was another example. He was at art school in Budapest and Berlin before he took up photography.

DH They were trained with a bit of draughtsmanship, meaning they were trained to look. Cartier-Bresson fitted perfectly into a technological period. To do what he did you needed the development of the faster film and the handheld camera – which was the Leica around 1925. That was the first practical and popular 35mm camera. Before the handheld came in, you needed a tripod for everything, so photographs couldn't be made quickly. The Leica made it possible to snap high-quality images. So Cartier-Bresson's era was the technological epoch between the invention of the 35mm and the beginning of the era when computers began to have an effect around 1980. He was the master of that period: a fantastic eye. He began when the Leica was invented, and he gave it up a little before Photoshop was invented. His rules – don't crop the picture, for example – would be incomprehensible to a young twenty-first-century photographer. You couldn't have a Cartier-Bresson again, because you would never believe it. Today it would be artificial.

MG Do you think photography has lost something with that claim to veracity, whether it was ever truly justified or not?

DH My argument is that there is a pictorial crisis in a way, but it's in photography and film. That's the twist. It's not about painting. Painting will always be there, although it's difficult for it to thrive if you don't teach it very much.

II

Caravaggio's camera

DH Because I'd done a lot of photo-collages in the 1980s,
I recognized these seams in Caravaggio. I knew a lot about
what they could be and that's what I saw.

MG You mean they were like the edges between two different
photographic exposures, the division between a Polaroid
taken at one distance from the subject and another from
a slightly changed position?

DH Yes. As a result, Caravaggio's figures don't quite sit
correctly in the space. In a composition by Raphael
or Rubens, you *feel* the figures in space because the artist
had sensed it in his head. Whereas, in a Caravaggio, they
are squeezed. But you have to point out the oddities in
his pictures; people don't see them. It must be something
about the power of naturalism. Have you noticed how
wide St John the Baptist's waist is in the painting in the
Nelson-Atkins Museum in Kansas City? It's incredibly
wide. That's the kind of thing Caravaggio's contemporaries
would have criticized. That his drawing is a bit odd.
I was in 'The Genius of Rome' exhibition at the Royal
Academy in 2001, looking at that painting, and somebody
came up behind me and said, 'C'est terrible!' I turned
round and it was Cartier-Bresson.

On the wall in front of me there appeared an extraordinary
image soft, delicate, upside down. It was at the same time start-

Caravaggio, *St John the Baptist in the Wilderness*, c. 1604–5

lingly real and different from reality. The surfaces of the objects – a couple of mandarins, a wine glass, a blue-and-white vase, some cheap cloth – looked exactly as they actually did, as I had seen them a few moments before, in full sunlight. But they were simultaneously transfigured: more sumptuous than when seen directly. The effect was both very real and – even in the twenty-first century – slightly magical.

A length of inexpensive red cloth, arranged in casual folds, looked like velvet. It seemed richer than in reality and also

somehow simplified. Its appearance had been concentrated into three components: a rich scarlet, a lustrous shadow, an intermediate zone of darker colour. It was impossible to resist the connection. You could almost see this image translated into decisive brushstrokes in oil paint by a seventeenth-century painter: Van Dyck, Vermeer, Caravaggio.

It was 28 October 2009, and I was in a back room of a purpose-built Victorian studio in Kensington – Hockney's London studio – looking at a still life assembled by his friend, assistant and collaborator David Graves. The image was created by a lens in a curtain across the entrance to the space I was in: a dark room or, in Latin, *camera obscura*. I was looking at what Hockney calls 'optical projections' as part of my preparation for writing a piece, an update on Hockney's theories about the Old Masters and cameras, for an art magazine, *Apollo*.

After a while, Graves reached forward to change the items in the still-life display, and his head suddenly appeared on the wall in front of me. Suspended in darkness – the product of the narrow depth of field and reduced quantity of light in the image – he looked extraordinarily like a Caravaggio. This fleeting image had much the same quality as in his painting, and other seventeenth-century pictures: it was like reality, but at the same time richer, more saturated. That resemblance of course does not constitute anything like art-historical proof, but it is enormously suggestive. Once you have seen optical projections floating on the wall in front of you it is hard not to believe that they would have made a powerful impression on any artist who saw them.

DH The Museum of Modern Art in New York put on a show called 'Before Photography' in 1981, when the rest of the museum was full of Picasso. I saw it and read the catalogue, which didn't mention that the artists just before

photography came along in 1839 were using cameras. It implied that they were just looking intensely, and then the photograph proved the intensity of their vision. That is a *terrible deceit.* It isn't what happened at all. Lenses can make pictures but, according to art history, hardly anyone used them until 1839. That couldn't possibly be true.

In 2001, Hockney published *Secret Knowledge,* in which he moved from making art to writing art history. His thesis was characteristically bold: that European painters had used, and had been influenced by, images made by lenses, mirrors and cameras for a long, long time before the official birth of photography: the invention of the daguerreotype by Louis Daguerre, a French painter, in 1839.

To an extent, Hockney's argument is a simple and undeniable one. The revolutionary novelty in the mid-nineteenth century was not the camera, but various chemical processes for fixing the images made by a camera. It was known to Aristotle that a small aperture between a brightly lit space and a dark one will create a dim image in the latter. He observed an image of an eclipse projected through dense foliage into the shade beneath a tree. This is how a pin-hole camera works; by using a lens, however, the quality of the image can be greatly improved. That this is so was known, at the latest, by the mid-sixteenth century. It was described in widely read books and noted as a marvel. By the late eighteenth century, various types of camera were manufactured for use by artists and members of other professions – such as cartographers. Some resembled large, unwieldy wooden boxes similar to the contraptions employed by old-fashioned photographers (without, of course, the film).

Some painters unquestionably owned these gadgets; Sir Joshua Reynolds had a camera now in the Royal Academy collection, for example. A number undeniably used them when

drawing and painting. All this is not so much secret knowledge as neglected knowledge, by art historians at any rate. Hockney's audacity was to claim that this process had been going on for far longer than had previously been suggested.

DH It is known and accepted that the camera obscura was used by artists in the mid-eighteenth century. Well, if that was true in the eighteenth century, a reasonable question is when did this begin? If it was known what the problems were then, well let's look back a bit. How do you look? You look at pictures. The evidence is *pictures*, not texts. Or rather, pictures *are* texts – and they'll tell you a lot.

A seventeenth-century camera obscura would generally have been closer to what its name suggests – a dark room. How it would – or could – have been used would have depended on a technical factor: the quality of the lens available. Hockney's thesis is that for his mature work Vermeer would have had a lens that would have been good enough to permit what in cinematic terms would be called 'wide-angle long-shots'. That Vermeer did something like this, though not completely uncontroversial, is edging towards a degree of consensus. Independently of Hockney, Philip Steadman made an immensely detailed and per-suasive study of how Vermeer might have worked (*Vermeer's Camera*, 2001). Steadman re-created one of the rooms seen in the seventeenth-century Dutchman's pictures, with an enclosed cubicle for the camera at one end.

It is far more of a jump to go back half a century from Vermeer in the 1650s to Caravaggio around 1600. This is a move into art-historical *terra incognita*. Hockney proposes Caravaggio would have had a lens that would effectively project a small amount of a subject: a head, a forearm, a bowl of fruit. These glimpses would have had to be stitched together in much the

way that Hockney constructed his Polaroid collages. Any small change in the relative positions of lens, subject and canvas would have created just those breaks in visual continuity – those 'seams' – that Hockney talks about.

DH The very subtle thing is that you can move the canvas or the model – the lens would stay where it is, it's fixed in the set-up. If you move either slightly too much or too little, it will be slightly too big or too small. There's no other way you would get that effect; you certainly wouldn't if you were drawing it freely.

These breaks are indeed visible in the paintings, which abound in anatomical and spatial oddities: arms too far, too short or too long; figures crammed into a visual space that is simply too small to contain them. This was commented on by Caravaggio's contemporaries. Gian Pietro Bellori, one of his earliest biographers, notes that the older painters of the day, devoted to an earlier style, complained that Caravaggio painted 'all his figures … on one plane without any diminution'. Again, that's not proof, but it's quite suggestive. Around 1600 Caravaggio came up with a manner of painting that was sensationally novel. Its features were dramatically dark lighting and intense realism. He always represented a real model or thing in a fashion so naturalistic that it astonished and shocked his contemporaries. In contrast, previous Italian painters had generalized and idealized what they saw. The image had been filtered through an intellectual process; Caravaggio seemed to be presenting prostitutes and people from the streets of Rome as saints. All of this could be explained by his use of a camera-like technique.

DH The criticism would have been exactly the same if he had been using photography. The models for saints wouldn't

Caravaggio, *The Entombment of Christ*, 1602–3

have been aristocrats; they would have been people needing a bit of food or money.

But, it has been asked, why was the lens necessary? Why could he not just have posed his models in a strong light in his studio and paint them like that? It's a good question. One reason for believing he did use a lens is the existence of those mistakes in drawing: the long arms, the figures like those of the *Entombment*, who are squashed into a space far too small to contain them. These are errors that are natural if the artist had been using a lens, fitting a series of close-ups together, but harder to explain if he had been drawing normally from the model. And to the question, Why bother with a lens, then? Hockney has an answer, from a painter's point of view. Seeing an object projected by a camera obscura, the way I saw David Graves's head, makes it much easier to translate into marks on a flat surface.

DH A lot of people commenting on *Secret Knowledge* have never looked at projections, which you really should, because as soon as you see them you realize that the simplification in them is precisely what painting did. Sometimes you see much more in a projection than your eyes would ever take in from the object itself, especially textures such as those of cloth, patterns on fabrics. For instance, we rented some armour with a shine and a matt polish. When you see that armour in a projection you can grasp easily that really just three greys, a white and a black are enough to paint it; but if you are looking at it in three dimensions it's much harder to see that, just as it's much harder to see where shines are on a glass.

There is a great deal of resistance to this line of thought. As Martin Kemp wrote in *The Science of Art*, 'Art historians have

generally been reluctant to study the implications of this evidence, feeling, no doubt, that it is not quite proper for their favoured artists to resort to what has become regarded as a form of cheating.' That attitude is still common. Scholars of Canaletto have denied that he used a camera obscura, although contemporary writers emphasized that he did; there is a camera obscura in the Museo Correr in Venice inscribed with his name; and drawings by him exist that were quite obviously done with a camera (they have precisely the same tell-tale traced line that Hockney has pointed out in Andy Warhol's drawings from slides). Even historians who believe Vermeer used a camera sometimes minimize its importance: he used one, they argue, but it didn't really much affect his pictures. One way to address this argument is to deny, as Hockney does, that using a camera is cheating.

DH Optical devices are just tools. They don't make marks, they don't make the painting. You can draw using optical devices – and it actually is drawing, that is, an imaginative treatment of what you are dealing with. It's not just tracing something. In any case, I'm not suggesting that these artists projected a whole picture, then just traced it. That's not how it was done at all. I think Caravaggio made a sort of collage of elements pieced together very, very cleverly, very creatively. But it would have taken quite a bit of time to work out. Using a camera doesn't diminish these artists at all. No lens could see the whole picture of Vermeer's *The Art of Painting*, with everything in focus. No lens today could; no lens ever could.

The interest of Hockney's ideas about the art of the past is that they do just what he is often trying to do in his own pictures: bring things nearer. If you accept them, then Caravaggio and Vermeer suddenly seem much more like contemporaries.

They belong in the same narrative sequence as Henri Cartier-Bresson, Francis Bacon and the cinema.

DH There's a whole history that has just been ignored.
A history that doesn't reduce what had gone on at all;
in fact, it brings it closer to us and makes it incredibly
more interesting to me, especially in the case of an artist
such as Caravaggio. He invented a black world that had
not existed before, certainly not in Renaissance Florence
or Rome. Caravaggio invented Hollywood lighting.

12

Way out west: space exploration

During the dark months of the late autumn and early winter of 2009, Hockney was returning to the United States, a place where he has lived intermittently since he first visited it in 1964. It has always been the west of the country, not the east, that has called to him.

DH I feel I'm an English Los Angeleno. I've been there a long, long time. It's affected me. I'm Americanized in many ways. I was eighteen years old when I first visited London – which was quite late. I was born just before the Second World War and you didn't travel much in those days. There was a slogan during the war: 'Is your journey really necessary?' We didn't even know people who had been to London – it was a long, long way away. Now I've lived in LA a lot more than I have in London.

On this trip he was planning to visit New York, then stay in Las Vegas at the Venetian hotel. 'It's very funny; you can go on boat rides in a real gondola, but one ride is indoors through a shopping mall.' It sounds like a perfect example of West Coast American architectural fantasy. The playfully – even absurdly – theatrical side of Hollywood has always appealed to Hockney, who can be a playfully theatrical artist. But much more important to him are the space and light of the western landscape. This is, echoing the title of a movie of 1958 starring Gregory Peck and Charlton Heston, *The Big Country*. After Las Vegas, he revisited the Grand Canyon. He told me about it after his return.

Canyon Painting, 1978

James Ward, *Gordale Scar, c.* 1812–14

DH Last November we went out to the North Rim of the Canyon, just before they closed it, which they do annually before the snow starts. It's a thousand feet higher than the South Rim. Not a lot of people go, and they'd have to use a snow plough on a little road to keep it open. We were among the last people there. Oh, I *liked* that. I like silence and I like solitude. That's why I'm not that keen on the big city.

MG On a mountain you get that sense of exhilaration when you get to the top, looking down on the world below.

DH Yes, that's right. It's a long time since I've been down to the bottom of the Grand Canyon, although I have done that. I went there nearly fifty years ago in 1964 on a mule. But for me the biggest thrill is standing on the top, looking

down, as you do from a mountaintop. It's the same
with Zion Canyon in Utah: there are fantastic views
where you can see the edges of the space in front of you;
it's wonderful and *big*. You get the same sort of feeling
in a great cathedral, of course, but it's not as big as nature.
You can see why the Mormons called that place 'Zion'.

One of my interests in the Grand Canyon was that
when you go to the edge there you just *look*. There are not
many places in nature where you do that; you just stand in
one place and start *looking*. Yosemite is nearer to LA than
the Grand Canyon and it has similar spaces. You can drive
there in five hours; the Grand Canyon is a ten-hour drive.
To go to Yosemite from LA, you drive up to Fresno, then
into the sierras. You keep going higher and higher. You
are aware of that; signs keep telling you the height above
sea level: 4,000 feet, 5,000 feet. Pine forests begin. As
you approach Yosemite itself, you are conscious of a great
valley down to your left. Then you go through a tunnel,
and immediately there is a car park because the moment
you come out it is so spectacular you put your foot on
the brakes. Everybody does. You see this incredible valley,
verdant at the base and with big waterfalls, vast canyon
walls. It's truly spectacular. People just stand and *look* at it.
It's the space that is thrilling. It's quite something.

MG There are grand landscapes much closer to Bradford than
the Grand Canyon.

DH The west Yorkshire landscape is spectacular in Wharfedale
and Airedale. Of course that was painted by late-eighteenth-
and early nineteenth-century painters: Turner, John Sell
Cotman, Cornelius Varley and James Ward. I love Gordale
Scar. I knew it when I was very young; I used to climb up it.

The actual place is more dramatic than James Ward's picture. He's flattened it out a bit.

Space is an abiding preoccupation of Hockney's: space, and how to depict it on a flat surface – a picture – without flattening the space itself. Of course, in real landscape nothing comes bigger than the Grand Canyon. It's an epic piece of geology: a gulf in the Earth's surface the size of a mountain range but going downwards not upwards: 18 miles across, 277 miles long and in places over a mile deep. It provides the kind of sensation known in the eighteenth and nineteenth centuries as the Sublime – that is, nature on a scale that is beyond the human dimensions of the lowlands: thrilling, even frightening terrain. In painting terms, it is to move from Constable to Turner, from close-up to wide-angle long-shot of the sea, the sky, tempest, mountain peaks. In the late eighteenth and nineteenth centuries, these were frequent subjects for painters, not only Turner, but also Caspar David Friedrich in northern Germany, and North American artists such as Thomas Moran, Albert Bierstadt – who painted many pictures of Yosemite – and Fredric Edwin Church. Hockney admires works of the latter group, but only up to a point.

DH In the nineteenth-century American painting that was on show at Tate Britain in 2002, in 'The American Sublime', I always felt there was something missing. It was a terrific exhibition. I knew several of the paintings already and their subjects – landscapes in the western United States. I went several times. But I felt it's just not French painting. The brushstroke had been taken away, so there was no pleasure in the *doing* of the painting. Then I realized that those artists were looking at early photographs, and in a sense were imitating them by making everything smoother, as it is in a photographic image.

J. M. W. Turner, *Yacht Approaching the Coast, c.* 1840–5

Hockney first painted the Grand Canyon in 1978, shortly after his move to Los Angeles. That was a jolly painting in a fauvist spirit designed to allow him to try out some new, very bright acrylic colours. Vivid colour has long attracted him; it results from the Californian light, so different from that of Bradford. But that first *Canyon Painting* barely began to plumb the depths of that colossal gulf, slowly eroded by the Colorado River over immense periods of time. He returned, again and again.

In 1982, he went back to Arizona and took a large number of photographs of the Canyon, as he explained in his book *The Way I See It*. 'Because I hadn't seen the image immediately – as I would have done if I'd used a Polaroid – I had to remember what I had done. Memory became a part of the process.' In the late

A Closer Grand Canyon, 1998

1990s, he was back again, painting a whole series of multi-canvas pictures, among them the huge *A Bigger Grand Canyon,* made up of sixty separate canvas panels, with an overall size of almost seven feet in height by over twenty-four feet in length: huge for a picture. Yet, in comparison with the Canyon itself, obviously, it was tiny. As the Los Angeles artist Ed Ruscha remarked to Hockney when he announced he was off to paint the Grand Canyon, 'Presumably that will be a miniature.' Hockney still finds that funny.

DH When I painted *A Bigger Grand Canyon* in 1998 for an exhibition in Paris, they were done in the studio in LA from drawings. The second – which I called *A Closer Grand Canyon* because you feel closer to it – was done from

drawings after sitting there for a week. I took the chair
right to the edge to make sure I could sit comfortably for
quite a while. I'd be out very early when the sun had just
risen. I'd just sit there. Sometimes I even thought that
the whole thing could be flat. I've had weird thoughts there.
It's unphotographable. No photograph does it justice.

MG Why?

DH Because a photograph sees it all at once, in one click of
the lens from a single point of view, but we don't. And it's
the fact that it takes us time to see it that makes the space.

MG So how do you set about painting space?

DH I don't know, to be honest. I just do it by instinct. I don't think there is a formula. It's something that can't be measured, because it's in the head. The eye is part of the mind.

MG If the eye is part of the mind, that implies that the space you see is partly inside the head of the artist.

DH I've always been fascinated by pictorial space, because you can just *invent* it and make it work. That's what terrific artists do – Picasso certainly could.

MG Perhaps everybody does.

DH I've often pondered about that. Yes, we make the space. We don't see everything at once. The question is: What do I see first? What do I see second? What do I see third? I remember Jonathan Miller once said to me that we don't see space, we see objects. I replied, 'Speak for yourself.' Personally, I'm a bit of a space freak. I'm quite claustrophobic.

MG You think you personally have an unusual craving for space?

DH I sometimes think as I have got deafer I could see space more clearly. In fact, I suppose as a deaf person I could be compensating for my loss of sense of space through sound. But as an artist you would notice that your feeling for space had become more acute, as no one else might, because you would be thinking about it. That's got worse for me. I've had hearing aids since 1979; by then I'd lost 22 per cent of my hearing, so it must have started ten

years earlier. I stopped going to art openings, but it took me a time to realize that that was because I couldn't deal with the sound. Sometimes it terrifies me nowadays. If the phone rings I have absolutely no sense of the direction it is coming from.

MG At the Grand Canyon you are coming up against the limits of human perception. It's too big for us to grasp. Our senses aren't adapted to compute on that scale.

DH Most people think time is the big mystery, don't they? But you can't have time without space. There's a marvellous Wagnerian line, in *Parsifal*: 'Time and space are one.' That's from 1882, before Einstein. It's inconceivable to us to imagine that space might end, isn't it? What's there if there's no space? And when you are looking at the furthest places in the universe, you are looking back in time. Your brain begins to burst when you try to think about it seriously; you could make yourself a bit mad.

13

Cleaning Claude

It was 15 January 2010 and I was sitting in a West End restaurant listening to a speech by the director of a large American museum, when embarrassingly, but fortunately fairly quietly, my mobile telephone rang. I switched it off, and looked at it furtively during a break in the Powerpoint presentation. It said, 'David Hockney Missed Call: David Hockney Voice Mail'. Evidently, he was back from his trip to the States.

When the lunch was over, I called back. It turned out he had returned with an unusual piece of cargo: a disk with a high-quality image of an obscure painting by Claude Lorrain from the Frick Collection in New York. The painting, which I had never noticed, was called *The Sermon on the Mount* (*c.* 1656). Using the image on the disk, Hockney explained, he had 'cleaned' the picture using Photoshop, with the result that he now had a full-size photographic version of this mid-seventeenth-century picture, now utterly transformed. In this new Hockney version of the Claude, the colours were apparently bright and fresh as they might have been when it left the artist's studio three and a half centuries ago. It seemed details were now visible that previously were not. 'We found the lame and the blind in a pit. You began to understand how marvellous it would have been when it was newly painted, how fresh. It must have darkened greatly over the years.'

This was an extraordinary development in Hockney relations with art history. From having overturned the theory of the subject – with his theories about lenses, mirrors and optical projection – he had moved on to virtual conservation. What's more,

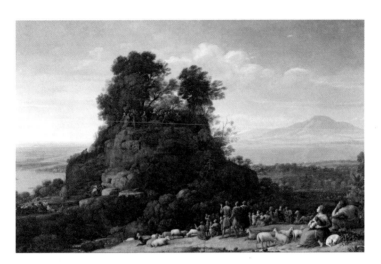

Claude Lorrain, *The Sermon on the Mount, c.* 1656

the cleaned Claude was now feeding into his own painting. Hockney had begun, he announced, a series of variations on this theme by Claude – 'It's a very rich subject for me.'

It all sounded intriguing, but also puzzling. I found out more a little later in the month when I went up to Bridlington again. My friend Vikram Jayanti, a documentary film-maker, offered to drive me, since he was keen to meet Hockney. I met him at Stamford on 21 January, a clear, sunny, bracingly cold day. We drove up the A1, then across Yorkshire to Bridlington, guided in by a series of texts that became slightly impatient as lunchtime approached. 'What on earth are you doing in Beverley?' read one of the later ones. It turned out we hadn't taken the fastest road, but we got there eventually.

In the studio, side by side, were the full-size photograph of the original, dark and uncleaned Claude, and next to it the light, bright, virtually cleaned image. It is, as was made apparent, a large painting – especially for Claude – eight and a half feet

across, and five and a half high. In Hockney's vast, light studio, however, these two images together didn't take up all of the long far wall by any means. Beside them were some canvases in which Hockney had begun exploring the picture in his own terms. In these, the gnarled and craggy knoll of Claude's painting, at the summit of which Christ was delivering his sermon, was glowing hotly red. 'I was thinking', said Hockney, 'of the heart.'

MG But why Claude? And why this particular painting?

DH It was mostly the space in the picture that attracted me.
I knew it was called *The Sermon on the Mount*, but if you
just see the painting in New York, its subject is not that
obvious. It's very dark, you don't see the figures clearly.
What you do see is something that appears to be like
an island rising out of the land. The sea is behind. When
I was in the Frick, I always enjoyed looking at it, for years.
It is a very unusual picture in Claude's oeuvre. It is not
written about much, possibly because it couldn't be seen
that easily. I got as many books about Claude as I could;
I read quite a few, quickly.

His pictures are theatrical; in fact, he did kind of invent
that theatrical landscape – with trees on either side and
deep space in the middle. But this painting is the one that's
different – the deep space is on either side and the thing
closest to you – the mount – is in the middle. Probably,
that attracted me. Perhaps it was the show at Tate Britain
last autumn, 'Turner and the Masters', that triggered
this new involvement with the picture. That had several
Claudes in it, hung beside the Turners that had been
inspired by Claude, and they looked marvellous. Then
I went in to see it at the Frick, and got the disk with the
image so I could start studying it here.

MG How did the cleaning actually work?

DH I did it using it the computer. You could be quite bold, because you weren't harming the original painting. It must be very delicate. The curator at the Frick told me it had been in a fire in the eighteenth century. But you can't see the whole thing that well on the computer simply because of the size of the screen. So I'd work quite a bit, then we would print out what I'd done at the size of the painting on two sheets of paper and join them.

It took a while. I did it quite thoroughly, not covering anything up but revealing more and more. I followed his brushstrokes. The printing was essential. Otherwise you couldn't see it whole. I'd pin the printout on my bedroom wall and spend the next night and early morning looking at it and deciding where to go next with the cleaning: making decisions, not doing them, just considering – that should come up now, that needs to be balanced over there. You need to look at the whole thing, and at a reasonable size – and what better size than the dimensions of the actual painting? We must have printed out six stages of it, which I've kept.

MG But how did you find out what the original colours were?

DH From other Claudes I'd seen. There's a palette to a Claude, certain colours that he used. Then you begin to find the equivalent in this printing machine. This is a reproduction, but it's very good quality. It was amazing how you could just lick off more and more, bit by bit. Just thinking, 'that green looks a little too dark', so you take off a bit more. When we got to the fourth stage of 'cleaning', I knew it would take three or four hours of looking at it, which I did

Claude Lorrain, *The Tiber from Monte Mario Looking Southeast, c.* 1640–50

again lying in bed. I might start at four o'clock and work for four hours, say, with Jonathan Wilkinson, my technology assistant, and then print one again.

MG So you were working on a virtual Claude as you might on one of your own paintings?

DH Yes. I was accepting the colours that the printing machine produced, but interpreting them as Claude. It's not oil paint, but I thought what we did made the picture more enjoyable – you could see more.

Having now read and thought about Claude as I never had before, I could see that there were several reasons why Hockney might be drawn to his art. Claude Gellée (*c.* 1600–82 or, according to some scholars, 1604/5–82), known as Claude Lorrain,

was one of the major sources for both Turner – as had been demonstrated by that Tate exhibition – and Constable. In other words, he was the origin of a landscape tradition to which Hockney had now attached himself. What's more, Claude was close to the beginning, if not the actual progenitor, of the practice of painting landscape outdoors, directly from nature – to which Hockney had recently and unexpectedly returned. Joachim von Sandrart (1606–88), a German painter and biographer tells a story about his much greater contemporary. Claude, according to Sandrart, was in the habit of 'lying in the fields' at dawn and sunset, closely observing his subject, then when he had contemplated it long enough, he mixed his colours on the spot and returned to Rome 'and applied them to the work he had in mind with greater naturalness than anyone had ever done'. Eventually, however, Claude met Sandrart at Tivoli when the latter was painting the famous cascade 'brush in hand' in the open. Then Claude apparently adopted the same method, sketching outdoors in oils. That anecdote – whether true or not, or a bit true and a bit boastful on Sandrart's part – underlines the truth that Claude, although he spent his adult life in Rome, was a painter in the naturalistic, northern European tradition. Originally, as his name suggests, he came from Lorraine, then an independent state and right in the centre of the artistic north: east of Paris, south of Flanders, west of the Rhine.

Claude's pictures have mythological and religious subjects, but fundamentally they are about light and space: wonderful airy vistas receding to blue hills in the distance or far out to sea. Constable admired the way he 'lived in the fields by day' – just as he did himself as a young man. In a picture of a goatherd piping in a glade of trees on a hot day, owned by his friend Sir George Beaumont, Constable loved the way Claude 'diffuses a life and breezy freshness into the recesses of the trees that makes it enchanting'.

In a letter to a Viennese patron, Count Friedrich von Waldstein, Claude revealed how he thought of his pictures himself. One he described was ostensibly of an Old Testament subject, Abraham and Hagar, but Claude wrote, 'that one is the rising sun', the other, its pendant, was 'the afternoon'. Changing light at different times of day was a subject Hockney himself was increasingly fascinated by, as he was by another forte of Claude's: trees.

DH A lot of his fame was because of the delicacy of the foliage in his pictures. The detail in his trees, just the way he does leaves, is wonderful. It probably isn't that natural, but it looks it, the way the edges of the trees are always very soft. Trees are like that. I read that when he was going to do a lot of painting first for about half an hour he'd put his hands in hot water. I thought, obviously, he's going to flick the brush very fast, to move the paint at speed. So he probably painted them very quickly.

MG Like a violinist.

DH Yes, with a very good technique. They are very, very beautiful pictures, beautifully composed, the spatial arrangements carefully organized. I've got a facsimile of a Chinese scroll from the time of Giotto. And there is a device in it that reminds me of this Claude, *The Sermon on the Mount*. You realize that as you are walking through the landscape you are being taken to different heights. You go up a mountainside to look down. There's a lake that you see at different levels. If you do it slowly, it's amazingly smooth. In Chinese art, it's called the principle of moving focus.

MG Claude makes space not so much with linear perspective as with what art historians call 'aerial perspective' – that is, colour and tone.

DH Yes, and also by giving you a slightly higher viewpoint. That's what an illustrator would use today if he wanted things receding, behind and behind. But *The Sermon on the Mount* is a picture about looking up, which rather fascinated me. The central figure is just off the centre of the picture, just right for the golden section. Knowing that wall at the Royal Academy, which is even taller than the one in my studio, I think it will be very effective there. The people in the painting are gazing at someone giving a sermon on a hill. You've got the focus of interest halfway up in the sky. It's very hard to do that in any other kind of painting. So the composition deeply attracted me. People say, isn't it a religious subject? Yes, I suppose it is, but only in a limited way. We've only found three other versions, so it's not like the Crucifixion or the Annunciation, a common religious theme. It's just someone giving a lesson on how to live.

Perhaps the idea of giving a sermon attracted Hockney too. On 16 March, a text arrived: 'We have begun a sermon on thirty canvases. I think it can make a picture for the twenty-first century. My title for this new painting is *A Bigger Message*.'

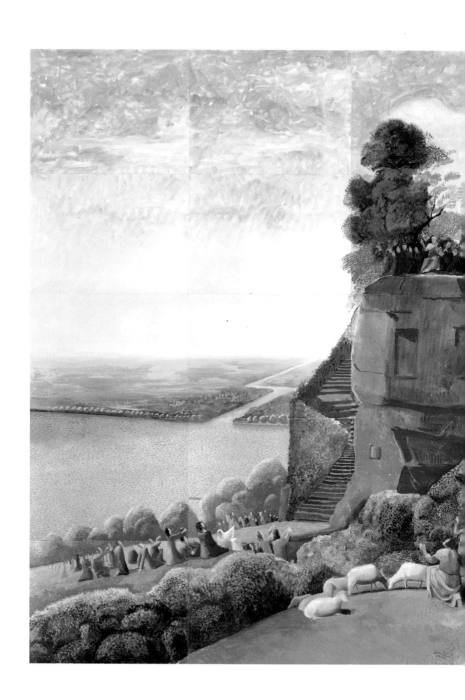

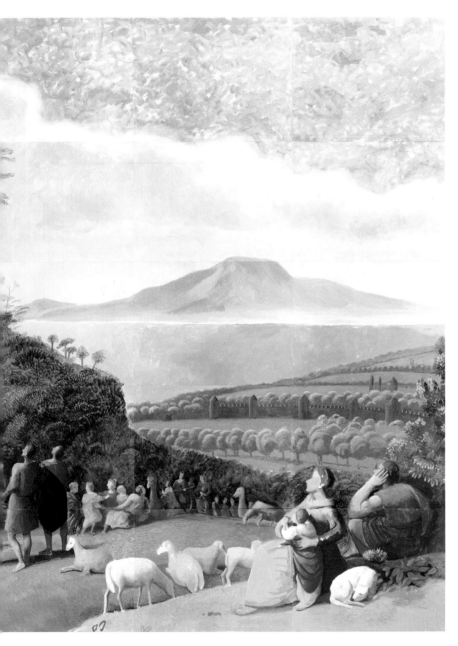

A Bigger Message, 2010

14

Movies and moving through the landscape

After lunch in the studio, we went back to the house to look at a new film that Hockney had made one morning a few weeks before, when the winter snow had just fallen. Jonathan Wilkinson, the assistant Hockney had mentioned and now an essential member of the Bridlington team, was in attendance.

The film was taken on a brilliant morning, the beginning of a day when Hockney had been invited to a wedding, which had limited the time for shooting. What they had shot, however, was remarkable. It was projected at a slower speed than real time, creating a slow progression through the frozen landscape that had a strangely powerful emotional effect. There is something inexplicably moving about light on snow. At this solemn pace, the experience reminded me of *Last Year at Marienbad.* Vikram, as a maker of documentaries, is much more familiar with the language of film than I am. He was greatly struck by this slow-motion snowscape and talked about it on the journey back:

I would have loved this shot for its atmosphere, for you could use it to suggest feeling. But he was using film to do something I would never have thought of doing. By making us watch twenty-five minutes of a journey that must have taken six or eight in reality, he's managed to find a way to force us to see what he sees in terms of *light*: his intensity of vision. The camera eye is staring with absolute concentration, well beyond the point where we would normally do ourselves. I try in my films to look

through other people's eyes. So I'm very sensitive to
when a camera can trick you into doing that. And here
by slowing it down, he allows us to see what he must
perceive in a millisecond.

This, perhaps, was a way in which to express a painter's view of
the world through film. It was also a work in progress. Hockney
showed us another experiment that didn't quite succeed: a screen
split into four, each showing differing images of a journey down
the road. This is an idea he has tried in the past. Recently he had
rediscovered a similar sequence shot for a television programme
twenty-five years ago in the mid-1980s. It showed a young man
walking down a staircase in Hockney's London studio, shot nine
times and the footage superimposed to create a sort of movie
equivalent to Marcel Duchamp's painting *Nude Descending a
Staircase, No. 2* (1912).

DH We did it for a television programme, *The South Bank
Show*. When we'd finished I said, if I could do it again we
could make it better. Melvyn Bragg said, 'It cost £22,000.
We can't do it again.' The amazing thing is that you
can do it at home now if you have the right equipment.

It seems the technology had now arrived – just as it had done
with computer drawing – to allow him to continue with the idea.

Hockney enjoys films. His home cinema is evidence of that.
He has after all, lived for many years on the doorstep of the
Hollywood dream factory. A film-maker friend he often refers
to is Billy Wilder, who died at the age of ninety-five in 2002.
He used to lunch weekly in a restaurant frequented also by
Hockney, who described how when the great screenwriter and
director entered, all the customers would stand up and applaud.

That sounds very much like Hollywood. Hockney likes to repeat Wilder's anecdotes. His favourite Sam Goldwynism, 'If people don't want to come to your movie, you can't stop them', he owes to Wilder. Hockney himself is full of cinematic recommendations. *Who Framed Roger Rabbit?* (1988) was one over which – to my surprise – he enthuses. 'It's full of very witty lines. Someone asks, "What do you know about show business?" The private eye replies, "It's like no business I know."' The film's appeal to Hockney must be that it plays constantly and imaginatively with the combination of drawn and photographed reality. Some of the characters and sets are Disney-like cartoons; some are real actors and props.

Another favourite, Fellini's *And the Ship Sails On* (1983), makes different visual jokes about alternative ways of depicting reality. It begins as a silent, black-and-white film, breaks into colour, and includes operatic passages and a ballet. Hockney loves works of any kind that play with the fact that what you are looking at is not the truth, but a work of art. He enjoys that in painting, at the theatre, and in the movies too.

DH It's great. In it there's a battleship, which looks like a
Cubist battleship. It's magnificent, a great big set made
of steel, with marvellous guns and big funnels on it.
At one point, when you see it, it's got real smoke coming
out of it; but the next shot it is stylized smoke, cut out
of cellophane. The point is to make you look and notice
these things. You couldn't say that it was more real than
an actual battleship at sea, but you could say that it was
more real than a *photograph* of a battleship.

Hockney obviously considers film, like photography, to be part of a wider history: they are all types of picture. That is one of the most unusual aspects of his approach to what – for want of a

better term – I'll call art history. Talking about how certain media and techniques lend themselves to certain subjects – as oils are good for painting flesh, for example – his mind jumps immediately to an example from Hollywood:

DH Billy Wilder told me that when Technicolor came in, it was used in *The Wizard of Oz, Robin Hood,* and so on. The studios quickly wanted stories that would show off colour: the nineteenth-century British army, with red coats, for instance. Suitable stories were found. The medium was dictating the kind of story. How are we going to get everybody dressed in *green?* In the Errol Flynn *Robin Hood* from 1938, Sherwood Forest looks incredibly green. The grass is a green you've never seen; it must have been painted. Will Scarlet is a wonderful, fabulous red you've never seen. It was probably very difficult to get. The costumes are superb. In those days, they considered what they should be made of and what colour they should be very carefully. That's the medium dictating a subject.

Jacques Tati, *Monsieur Hulot's Holiday*, 1953

Hockney is immensely interested in edges, both the edges of pic-
tures and the edges of items within pictures, such as the junction
where a face ends and the landscape behind begins. Listening to
him, you begin to grasp that visual art is, among other things,
all about edges. But one of the first cases in point that pops into
his mind is from a French film comedy.

DH Do you know Jacques Tati's *Monsieur Hulot's Holiday?*
There's a scene at the station in which the camera is fixed,
looking over the platforms. A train pulls in and everybody
runs down into the underpass, and you see them running
up on another platform. But it's the wrong platform. Then

another train starts coming in on another platform, and a further one here, you see them all running down the stairs again. There Tati is playing with space in a way that wouldn't be so interesting if the camera view were bigger. In other words, he's using the edges of the screen. He understood the flat screen, and what you can do with it. Really good film-makers do, and so do photographers.

Hockney looks at films with paintings in mind. On the other hand, Old Master painting puts him in mind of movies. Not only does he claim that Caravaggio invented Hollywood lighting, the entire process of putting together a big Renaissance composition makes him think of what went on at MGM or Paramount: the set, the complex choreography of the action.

DH Peter Greenaway made a series of film installations about the Veronese *Marriage at Cana* in the Louvre and other paintings. He uses various ways of emphasizing the drama and movement in the painting – he adds dialogue, for example. He's chosen pictures for which the modern equivalent might be a film. There are 126 characters in the Veronese doing various things and there are connections – lighting and all sorts of things – with motion pictures. When I read about Meissonier painting his picture *The Battle of Friedland, 1807* now in the Metropolitan Museum, and the research he did for it, I thought, 'This doesn't sound like a painter today. It sounds exactly like a film-maker.' Go on the location, get samples of the grass. These are exactly the sort of things somebody might be sent to do for a movie scene.

On the other hand, he isn't truly satisfied by moving photographs any more than he is by still ones.

Jean-Louis-Ernest Meissonier, *The Battle of Friedland, 1807, c.* 1861–75

DH I am from the last generation brought up without television; I was about eighteen when my family got one. But my father used to take us to the cinema when I was very young, and I loved it. We always sat right at the front, because the seats in the first three rows were sixpence in those days. Further back it was nine pence, then a shilling. So you looked up, and the screen seemed very, very big. And of course, it showed a marvellous, different world from the one you saw trudging through dingy Bradford streets to the cinema. If you had asked me then whether the edge of the screen mattered, I would have said, no, it was so big. It was enormous. But now, it is all too small for me.

MG Even at the cinema?

DH Yes, 'pokey' is my word. I went to see *Titanic* (1997), for instance, when it came out. Because I'd heard about

the way they used computers in it to create visual effects.
I went to see it on the largest screen in Hollywood,
and sat in the middle, to see it in the best possible way,
but after a while I felt I was looking through a letterbox.
But I concede that perhaps not many other people did.
I concede also that they might have gone to the film for
another reason: to be entertained. Whereas I admit I had
gone to look. I can't hear the dialogue very much, so
I only go to see films I think might interest me visually.

MG Is television any better?

DH Films generally have always been better than television:
the camerawork, level of photography, lighting and
so on. When I watch TV these days, I think: there's just
not enough to look at. That's always been one of my
complaints. It asks you to look at it, but then doesn't really
give too much actually to look at.

MG Do you mean there's not enough detail, or not enough
interest?

DH Both of those things, to me. CNN likes to think it is
showing you reality, whereas you might argue it's simply
showing you crappy art. Television tries to pretend you
aren't looking at a piece of glass, we are showing you
the real world. I was listening on the radio to someone
describing his mother who had Alzheimer's disease.
The television picture, to her, was just a lot of coloured
patterns. But actually that's precisely what it is, isn't?

About thirty years ago, Melvyn Bragg organized a
day-long seminar about the future of television. I went
along, and halfway through he came up to me and said,

'David, you haven't said anything, that's a bit unusual.'
I said, 'Well, I would have something to say. But you
and the other contributors are always talking about the
content. Why don't you talk about the very first thing you
see – which is the picture? And could I say my bit now?
It's not good enough!'

MG Not even these days, with high-definition and 3D?

DH I wasn't too impressed by 3D television. I thought it
would be great for pornography, because you get an
immediate sense for volumes. Probably not for much else,
otherwise it looks too toy-like. We've had 3D before,
they did *Kiss Me Kate* in 3D in 1953. There's something
wrong with it. We don't actually see like that. We scan
all the time, our attention shifts. For this, the camera has
to be fixed, it can't move too much. It's like someone
making a life-size replica of the world – where would you
put it? There's a point where you've got to interpret the
world, not make a replica of it.

Soon afterwards an email arrived. Hockney had been to the
barber's in Bridlington:

Yesterday I went to Fellas for a haircut. There were four
men waiting and a boy of about 12. I sat down and was
a bit annoyed with myself for not bringing a newspaper
to read. So I looked around. To my poor ears there was
some monotonous music pounding away and a screen
with a picture on it. I watched for a bit, but was really
struck how pokey it seemed, a different image every
second, if that long. There was a table with magazines:
various sports, soap-opera weeklies. Most looked pretty

much the same, their covers hardly differing, no matter
what the subject. Same kind of printing, each page
a visual hodgepodge – no one seemed to have space
around them.

Around this time, Hockney began to experiment with a novel
kind of moving picture of his own, using nine high-definition
cameras mounted on a car, the results shown simultaneously
on a screen split into nine sections, a little like his nine canvas
paintings, but moving and with each image seen from a different
point of view. Another message came: 'I suspect that 9 cameras
could open up new ways of narration. It's as though we are
making a very fluid lens.'

15

Music and movement

In *Picture Emphasizing Stillness* (1962), Hockney painted two men menaced by a leaping leopard. Above them is written a short sentence in script so small you have to move quite close to the canvas to decipher it. It reads: 'THEY ARE PERFECTLY SAFE THIS IS A STILL'. That picture from fifty years ago was – and remains – typical of Hockney in its wit. It also contains a characteristic thought: 'although it looks as though it's full of action, it's a still – a picture cannot have any action'. Trying to reconcile the stillness of pictures with the incessant mobility of the world is a problem that Hockney has mused on for decades. His latest solution, as we shall see, is to make high-definition Cubist movies – that is, pictures that have the multiple viewpoints of a still life by Picasso or Braque from around 1910, but which move.

In many ways, the environment in which Hockney grew up was closer to Victorian Britain than to the modern world. For his family, there was – crucially – no television and also no motor car. Subsequently, cars, and the mobility they bring, have played a surprisingly large part in Hockney's life and art. In *David Hockney by David Hockney*, he described how he first learned to drive, in Los Angeles in 1964. He arrived in the city not knowing a single person. 'People in New York said "You're mad for going there if you don't know anybody and you can't drive." They said, "At least go to San Francisco if you want to go west." And I said, "No, no – it's Los Angeles I want to go to."' A New York gallery-owner friend rang up a Los Angeles art dealer he knew, and the latter picked up Hockney at the airport and took him to a motel.

I got into this motel, very thrilled, *really* thrilled, more
than in New York the first time. I think it was partly
a sexual fascination and attraction. I arrived in the
evening. Of course, I'd no transport.... I was looking
for the town; couldn't see it. And I saw some lights
and I thought that must be it. I walked two miles, and
when I got there all it was a big gas station, so brightly
lit I'd thought it was the city.

His next attempt involved buying a bicycle – the method by
which as a boy he had got around the Yorkshire countryside:

I had read John Rechy's *City of Night*, which I thought
was a marvellous picture of a certain kind of life in
America. It was one of the first novels covering that
kind of sleazy, sexy hot night-life in Pershing Square.
I looked at the map and saw that Wilshire Boulevard,
which begins by the sea in Santa Monica goes all
the way; all you have to do is stay on that boulevard.
But of course it's about eighteen miles, which I didn't
realize. I started cycling. I got to Pershing Square
and it was deserted; about nine in the evening, just got
dark, not a soul there. I thought, where is everybody?
I had a glass of beer and thought, it's going to take me
an hour or so to get back; so I cycled back and I thought,
'This just won't do; this bicycle is useless. I shall have
to get a car somehow.'

Within a few days of arriving Hockney had learnt to drive, and
got himself a car (not in that order). He had also driven to Las
Vegas and back through the desert, found himself a studio and
begun painting. 'And I thought to myself, it's just how I imag-
ined it would be.'

Santa Monica Blvd, 1978–80

Hockney's interest in movement did not begin then, in his first week of living in LA. Like most deep impulses, it seems to have been innate. It is connected to his strongest psychological urge of all – one would guess – which is to *see* as much and as clearly as possible.

His move to LA in 1978 was the impulse for a series of what – borrowing a tag from Hollywood – you could call 'road pictures'. The first of them was significant above all for its failure. At two points in his career Hockney has found himself unable to complete large, ambitious paintings. In this case, the reason was because he was trying to do something that was impossible – given the methods of composition and visual construction he was using at the time. He wanted to paint a picture of Santa Monica Boulevard. But the streets of LA are different in kind from those of Bradford or Paris.

DH Of course, in LA the car plays a big part in your life. It's how you move around, you're forced to drive. If you walk along the boulevards it looks a bit blank, but if you drive you discover that a lot of the architecture and the signs are made to be looked at at thirty miles an hour, whereas Rome, for instance, is made to be seen at two miles an hour. In Rome, you're better off walking. But in LA, if you are looking for a shop, there will be a big sign above the little building so you can recognize it at speed. The architecture is meant to be seen when you are moving fast.

The painting *Santa Monica Blvd* (1978–80) was a long rectangle – twenty feet across. But the concept was static. What Hockney had produced, up to the point he abandoned it, was a grand, almost panoramic image of people walking on a pavement, with a parked van at one end. In other words, he had laboured at a still painting of a subject that was mobile: a streetscape intended

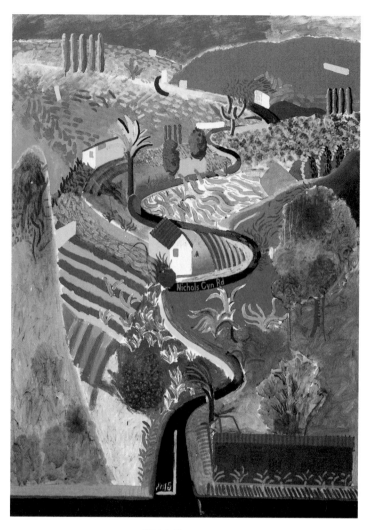

Nichols Canyon, 1980

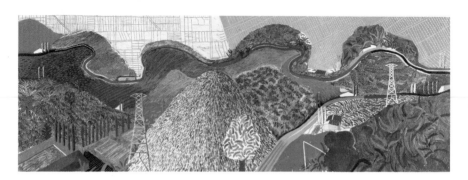

Mulholland Drive: The Road to the Studio, 1980

to be seen from a moving vehicle. His next road pictures took that into account. In 1979, he moved into another of Reyner Banham's four Angeleno ecologies – the Hollywood Hills – while keeping a studio on Santa Monica Boulevard.

DH If you don't live there or know people there, most people don't venture into them because it's easy to get lost. Along Mulholland Drive at the top, only certain roads go all the way down, and if you don't know them you might think you are going down but you just return to Mulholland Drive. Once I moved up there, LA became a bit different. It was less a matter of straight lines; you are on a wiggly road like Nichols Canyon, Mulholland Drive or the route down to my studio at the bottom of the hill. I did quite a few paintings about driving.

In 1980 he painted two big road pictures, *Mulholland Drive: The Road to the Studio* and *Nichols Canyon*. Those paintings, unlike the ill-fated *Santa Monica Blvd*, are pictures about making journeys. As you look at them, you follow the line of the road; mentally, you are intended to be travelling along it. Hockney made the point that the word 'drive' in the title *Mulholland Drive* refers to the street name, but also to the act of driving. The viewer's eye is supposed to move over the canvas at about the rate a car would move over the tarmac, recapitulating Hockney's daily trip down the wiggly roads to his studio.

In 1988, he followed these pictures with *The Road to Malibu*, which sets out another itinerary, to a new studio, so clearly that Hockney claims you could follow it, as on a map. There are 'reference points and road signs'. Later still, he devised his least known and – perhaps – most remarkable pieces of Los Angeles road art. These were not paintings, however, but events – a certain route, at a particular time of day, to a carefully prepared

The Road to Malibu, 1988

sequence of music. You could think of these works as a private –
and completely unreproducible – blend of Hockney's landscapes
and his work during those same years for the opera.

DH I suppose my musical drives around Los Angeles were a
kind of performance art. Because performance is now, isn't
it? There were several. I had a Mercedes convertible, and as
I was going deafer I realized that it was harder and harder
to hear music in the car. Living in LA you want music
when you drive, because you're in the car for a lot of the
time. So I had a better system put in, with more speakers.
 I'd just got a little house in Malibu at the time, and
I was driving around to explore, playing Wagner a bit
loud to test the speakers. Then I suddenly thought,
'My God! The music matches these mountains.' So slowly,
I choreographed a drive starting from the house. I finished
up with two: one about thirty-five minutes long; the
other an hour and half. I could time them with the sunset.
I'd tell people that they had to come at a certain time and
they couldn't be late because nature is doing the lighting.
There'd be, for example, the great crescendo in Siegfried's
funeral music, and you'd come round a corner and as
the music rose you'd see the setting sun suddenly revealed.
It was like a movie. What you were seeing and what you
were hearing came together in a fantastic way. Even kids
who you'd never get to sit still and listen to music enjoyed
it in a moving car. They saw that what I was doing was
telling you to *look*. Someone wanted to film it, but I said
it is a four-dimensional experience, minimum. I did it
in an open car, so you could look around in every direction.
I knew what speed to go at, when to press my buttons
to change the music. It took some time, but if I did it well,
everything fitted marvellously. My timing could be

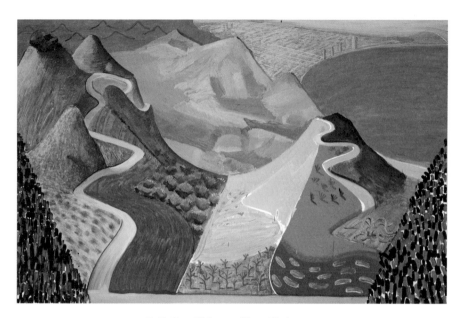

Pacific Coast Highway and Santa Monica, 1990

Wang Hui and assistants, *The Qianlong Emperor's Southern Inspection Tour,
Scroll Six: Entering Suzhou and the Grand Canal,* 1770 (detail)

slightly off if I got out of practice. I'd realize that I was
a tiny bit late with this; then I had to speed up. It was like
conducting the music really.

The *Pacific Coast Highway and Santa Monica* (1990), he's noted,
would be instantly recognizable to anyone who's been on one
of his Wagner drives. Some years before, however, Hockney had
encountered a non-European tradition that represents move-
ment and space in exactly the way he had begun to do so himself,
and indeed went much further.

DH I really began to get interested in Eastern art when I went
to China in 1981. Then afterwards I got to know the Far
Eastern Art curator at the Metropolitan Museum of Art in
New York, who showed me this great scroll in 1986. One
Sunday he said, 'Come in. I've got something incredible to
show you.' And on the floor of an upstairs room, they had

unwound a scroll about ninety feet long. I was there with
David Graves and we were looking at it for three or four
hours on our knees, and we thought that was just a *glance*.
There must be two thousand figures in it, we thought, all
doing things, all interesting. It was a fantastic experience;
one of the most memorable days of my life. It dated
from 1770 – about a hundred years after Vermeer. You
moved through a whole city, with the Emperor passing,
there are actually three thousand figures in it, all with
different traits and characters. Then the same day they
said, 'Would you like to go downstairs and see something
else?' They had an early nineteenth-century circular
panorama of Versailles. You had to go and stand on a
platform in the centre to view it. Then, if you turned
round, you saw the palace and gardens and so forth. I said,
'I see why you brought us here. We're stuck in a fixed
point. But in the Chinese scroll we've just been travelling
through a great city. There's a big contrast.'

Canaletto, *Campo di SS. Giovanni e Paolo, c.* 1735

At that time, not many in the Western art world knew much about these scrolls. They can't be reproduced in books, because of the way you view them, unrolling section after section. In fact, very few people have seen them properly, winding them themselves. You don't entirely unravel a scroll; you turn it continually. So it doesn't really have edges on the sides. The bottom edge is you, and the top edge is the sky. Therefore, you can't see a scroll in a book, because in a book the page turns over on itself.

MG It is a kind of painted movie, then.

DH In fact, we made a film about the scroll with Phillip Haas in 1987, and pointed out that the film was a sort of scroll, in which your viewpoint changes constantly as the camera moves. The film lasts forty minutes and the camera never stops moving. We then found out that the Chinese had rejected the idea of a vanishing point in the eleventh century because it meant that you – the viewer – weren't there. You weren't moving. If you're not moving, in a way you're dead.

MG That relates to the landscape videos you are making now.

DH Oh, yes. In those you are moving through a scroll. And film *is* a scroll. We had a Canaletto view of Venice on the wall in the LA County Museum when we were making the film about the scroll. I said, 'Please leave it because it makes a marvellous comparison.' In the Chinese painting, you are journeying through the landscape. When you get to the great city of Wuxi, you go over the wall into courtyards, backstreets. You see shops selling hats, shops selling pancakes. You can't go over a wall in a Canaletto.

MG There is a kind of European Baroque painting – Tiepolo's ceiling over the grand staircase in the Prince-Bishop's Residence in Würzburg, for example – in which the spectator moves; and as you move, you see the painting revealed above you.

DH But the figures never look odd, do they? They work from every angle. We went there last year and looked at them from every corner, and from across the space, and they always look right. Amazing, actually that staircase is just fantastic. The colour is wonderful. It's one of the best things of the eighteenth century. When I was standing there looking up at it, I said to John, 'Imagine what fabulous theatre it would have been to stand here in the eighteenth century, with all the people coming up and down that grand staircase, all the flunkies at the side. Looking at the ceiling, looking at them. It would have been incredibly splendid.'

MG It *is* theatrical, but the biggest stage is above you.

DH I bought a book, but it doesn't tell you how he did them. The drawing is astonishingly ingenious.

Van Gogh and
the power of drawing

The event of early 2010 in the London art world – at least for those who love painting and drawing – was an exhibition at the Royal Academy entitled 'The Real Van Gogh'. It was the most spectacular array of that supreme artist's work ever to have been assembled and seen in Britain. I went to see the show several times, for pleasure, to review it and also because I was asked by the *RA Magazine* to interview three artists about their reaction to the exhibit. They were Jenny Saville, John Bellany and Hockney. Each of these painters saw something different in van Gogh, in each case – I think – something that was really there. Jenny Saville saw the frenzy of working in searing heat, as she had done for a number of years herself in Sicily, and also Vincent's neuroticism:

> He uses exaggeration – a classic narcissistic way
> of being, which would go with his illness. I would have
> thought he was bipolar. Obviously when it was very
> severe he couldn't work, but his work is interrelated
> with his personality as a whole – not separate from
> his work at all. When van Gogh uses reflected light,
> say of the side of a jug, he exaggerates it. It's like a
> hyperbole, and that is reflected on a wall, so everything
> – colour and light – vibrates within the picture.

Bellany, on the other hand, stressed the psychological suffering of the artist:

That sense of inner turmoil is at the core of so much of his work. It's always there. And death is always present in some part of the picture.

Van Gogh was one of the causes of these conversations between Hockney and me. In 2006, a month or two after I published *The Yellow House*, a book about van Gogh and Gauguin's short period of life together in Arles in autumn 1888, he had telephoned wanting to talk about it. As he did so, I understood why he was strongly interested in the subject I had written about.

It wasn't just that van Gogh was a painter he revered, as almost all painters do. It was also because he was an artist who had been working in a remote provincial town – Arles – far from the metropolis. So, of course, was Hockney, though his circumstances were enormously more congenial that van Gogh's in his Yellow House. But Hockney, too, was living in an outpost, from the art world's point of view, surrounded by his subject: the East Yorkshire landscape. 'If Vincent hadn't been isolated like that', Hockney mused on the telephone in February 2010, 'I doubt he would have been able to get so far, so fast.' That was one of his insights into van Gogh's art; another was the transformation of vision that would have been caused by moving from a northern light, from a cold country to a hot one (just as Hockney had done himself).

DH It's obvious that he could already see a great deal when he was still in the north. But there's an extra clarity that occurs in the south – where we all see a bit more simply because you don't have misty horizons and water vapour in the atmosphere. Being in the south of France obviously gave Vincent an enormous joy, which visibly comes out in the paintings. That's what people feel when they look

Vincent van Gogh, Letter 628 to Emile Bernard, Arles, Tuesday, 19 June 1888

at them. They are so incredibly direct. I remember in some of his letters, Vincent saying that he was aware he saw more clearly than other people. It was an intense vision.

MG The day before he began on the first painting of his bedroom in Arles, he complains in a letter of having very

tired eyes. Then he slept for a very long time, and woke
with an idea for the painting of the room where he had
rested. One of the criticisms his neighbours made was that
he was always peering at things. It struck them as strange.

DH [laughs] Yeah, yeah, I'll bet he did. Yes, he would have
peered a lot – he must have been doing some very
concentrated looking. My God! After working for a long
time, I get very tired eyes. I just have to close them. It's
because of the sheer intensity of your gaze; to achieve
that you are using certain optic muscles and they tire,
as any muscle will. Sometimes, here at Bridlington, I just
cannot keep my eyes open. I get into bed and that is *it*.
I just have to close them immediately.

 The first twenty years of my life were spent in
Bradford, even farther north than van Gogh's youth in
the Netherlands, and of course that colours the way you
look at things. Bradford never really had shadows,
because it never had bright sun.

 The light is ten times more intense in California.
That's why Hollywood is there, because of the abundance
of fantastic light. Even after being in California for twenty
years, every morning I thought, 'Oh, it's a lovely sunny
morning!' Whereas if you'd been born there, you'd just
think, 'Another morning'.

MG Just about everything van Gogh saw in Arles struck
him as fascinating. Think of the subjects of his paintings:
the nondescript square where he lived, the little
municipal park, the railway bridge over the street, two
very ordinary chairs.

DH Photographs of those fields around Arles that van Gogh

painted wouldn't interest us much. It's a rather boring, flat landscape. Vincent makes us see a great deal more than the camera could. With a lot of his work, most people who actually saw the subject would think it was incredibly uninteresting. If you'd locked van Gogh in the dullest motel room in America for a week, with some paints and canvases, he'd come out with astonishing paintings and drawings of a rundown bathroom or a frayed carton. Somehow he'd be able to make something of it. I think van Gogh could draw anything and make it enthralling.

MG He was working under amazing pressure. His whole career – from the moment he abandoned preaching and took up painting seriously to the day he shot himself in 1890 – lasts barely a decade.

DH And it's true that all the incredibly great work by van Gogh was done in less than two and a half years, from the time he set out for Arles in early 1888. One marvellous thing after another. That's true of everything you see in the exhibition. But when van Gogh is described as self-taught, you have to remember that every person is mostly self-taught about drawing.

Above all, it was van Gogh's drawing that fired Hockney eloquence. Talking about van Gogh's drawing rapidly led on to Rembrandt. I was reminded of a remark of van Gogh's, in one of his maddest letters written just after he had visited the art gallery in Montpellier with Gauguin, and a week or so before he mutilated his ear. When talking about Rembrandt with Gauguin, he insisted, 'We've been right in the midst of magic.' Rembrandt, he believed, was a magician. Hockney thinks much the same of van Gogh, and Rembrandt, and Picasso too.

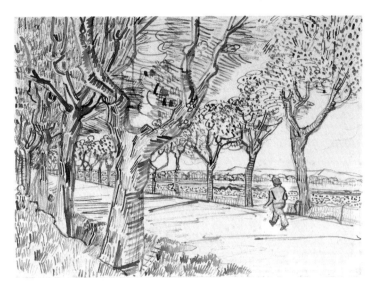

Vincent van Gogh, *The Road to Tarascon with a Man Walking*, April 1888

DH I think van Gogh was one of the great, great draughtsmen.
I love the little sketches in his letters, which seem like
drawings of drawings. They are condensed versions of the
big pictures he was painting at the time, so that Theo and
the other people he was writing to could understand what
he was doing. These days he'd be sending them on his
iPhone. When you look at them, they contain everything.
It's all there. He certainly didn't do anything by halves.

Those early drawings of the peasants are incredibly
good, technically. You really feel volume, get a sense
of the body and the texture of the fabric of the clothes they
are wearing – and yet they transcend that, because the
empathy is so strong. But technically they are as good as
any drawing you'll ever see. Rembrandt could do that too.
You feel whether the clothes his figures are wearing are
ragged or a refined cloth, even if he has just used six lines.

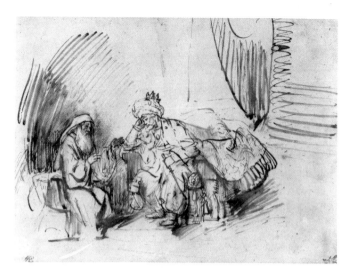

Rembrandt van Rijn, *Nathan Admonishing David*, c. 1654–5

With a truly great draughtsman, there is no formula. Each image is something new. It is in Rembrandt, Goya, Picasso and van Gogh. You never get a repeat of a face in Rembrandt or van Gogh; there's always something of the individual character. I love looking through the Benesch catalogues of Rembrandt's drawings; I keep one set in LA and another one in Bridlington. They are endlessly good for entertainment, better than films. Looking at them is an incredible pleasure.

With Rembrandt you never get a generic face, the eyes are always amazing. In a slight elongation of mark – just a little line and a blob – a set of eyes becomes old and tired. You can tell just where they are looking. Every face is different, just as it is in reality. He was wonderful at old men. There was incredible empathy. To me, the drawings are the greatest Rembrandt; the paintings are wonderful, but these are unique.

MG He picks up on the most expressively crucial bits – the eyes you just mentioned, for example.

DH That's what we'd see in real life if we were looking. We'd notice straight away the old hands, the sad face. That's why Rembrandt's so human. Anybody who's ever drawn very quickly sees how wonderful Rembrandt's drawings are; the economy of means takes your breath away. The hands, for example, can be quite crude, but in another way you totally get them. He can draw old hands in a couple of lines. Often you can tell that a certain line must have been done very fast. You can see the speed.

MG Similarly, when you are looking at a van Gogh drawing of a cornfield, in a way you are seeing his own energy.

DH A line has a particular speed to it, you can tell. Just the difference between this [he draws a rapid line on a pad] and this [a slower line]. Yes, you generally draw at various speeds. I think most people do. You can see it in Picasso; you can see it in Ingres.

MG In a way, then, drawing is a performance art. But it must also be a mode of thought. When you are working, are you consciously thinking, 'How do I translate this into marks with a brush, pencil or pen?'

DH Yes. When you are drawing, you are always one or two marks ahead. You're always thinking, 'After what I'm doing here I'll go there, and there.' It's like chess or something. In drawing I've always thought economy of means was a great quality – not always in painting, but always in drawing. It's breathtaking in Rembrandt,

Picasso and van Gogh. To achieve that is hard work, but stimulating: finding how to reduce everything you're looking at to just lines – lines that contain volume in between them.

MG Drawing, then, has a lot to do with making decisions as well as making marks. I suppose there are motor skills in your hands and your wrists, but there is also a mental process going on. It's a way of thinking, as well as a way of seeing and a method of working.

DH I thought one of the saddest things ever was the abandonment of drawing in art schools. Even if in the end everyone is self-taught, you can still teach quite a bit in drawing. You can't teach someone to draw like Rembrandt, but you can teach them to draw quite competently. Teaching someone to draw is teaching them to look. When it was given up, I kept arguing with people. They said we don't need it any more. But I said that giving up drawing is leaving everything to photography, which isn't going to be that interesting. At one meeting I went to, they said, 'Oh, I see it's back to the life room, is it Hockney?' I said, 'No, *forward* to the life room!'

17

Drawing on an iPad

A little after Easter 2010, another text arrived: 'I have got an iPad, what a joy, much bigger than an iPhone. I am drawing on it now, you will start getting new, bigger pictures. Van Gogh would have loved it. He could have written his letters on it as well.' Soon, the first iPad drawing arrived in my inbox. If his conversion to the iPhone as a medium was quick, his adoption of the iPad was even more rapid. This world-changing device had been announced on 27 January 2010 at the Yerba Buena Center for the Arts in San Francisco by Apple's CEO Steve Jobs. Hockney sent me his first iPad drawing on 6 April. He was still enthusing next time I saw him, later that month.

DH I love it, I must admit. The iPad can be what you want it to be. You could spend your time playing games, doing crosswords, watching YouTube, surfing the net or, like me, draw on it. Picasso would have gone mad with this. I don't know an artist who wouldn't, actually. I thought the iPhone was great, but this takes it to a new level – simply because it's eight times the size of the iPhone, as big as a reasonably sized sketchbook.

On this, rather than using just his thumb, Hockney drew with all his fingers, and eventually with a stylus. He opened his jacket to reveal a large internal pouch, a little like the ones poachers used to have to conceal game. 'I was in the boy scouts and I'm prepared for most things. I have a pocket for sketchbooks in every suit I own. Now I'll carry this.'

This technological romance proved longer-lasting than the one with the iPhone. It is still continuing as I write. Day by day, I watched him explore the range of different marks and textures the iPad and Brushes app together could make. He used soft brushy strokes like those that a big whiskery paintbrush might make, and sharp ones as if jabbed with a spiky quill pen. Another setting of the program – a virtual palette of colours and tones and intensity of hue – produced a pointillist field of coloured dots. On 1 June, at 4.57 in the morning, he sent me a Seurat-like study of the view from his window, with the comment 'a very misty morning here'. That view appeared in dozens of varying states of light and weather, and a profusion of graphic equivalents. The view from Hockney's window arrived in dawn light, half light, full daylight, with the lamp turned on inside the window, under snow, thawing, with rain spattering the glass between you and it. It was a visual diary, and a demonstration of how the most ordinary sight – what you see when you open your eyes in the morning – can turn into a theme for art, and an infinite one too. In a way, here was a digital successor to Monet's series paintings of such subjects as haystacks, poplars and Rouen Cathedral at different times of day. But part of the novelty of the iPad was its spontaneity. Hockney carries it with him everywhere, so he is – boy scout-like – always prepared to make a drawing.

DH The great thing about the iPad is that it is like a sketchbook, but you have the whole thing with you all the time with all the paints ready to use. I said that to my friend Maurice Payne the other day when he was here. I said, 'Look at that.' And there on the table in front of me was my cap. I drew it then and there and Maurice watched me. I said, 'It's only because I've got this to hand that I can just react to the cap over there.' Otherwise, I would

Untitled, 26 May 2010, iPad drawing

Untitled, 7 August 2010, No. 1, iPad drawing

Untitled, 6 August 2010, iPad drawing

Untitled, 31 December 2010, No. 1, iPad drawing

Untitled, 13 November 2010, No. 1, iPad drawing

Untitled, 6 January 2011, No. 1, iPad drawing

Untitled, 18 December 2010, iPad drawing

Untitled, 20 November 2010, No. 2, iPad drawing

have had to get up, get a sketchbook and materials. That's why you wouldn't have had the drawing of the cap. It was drawn in five minutes. Like a lot of the iPad images, it's playing with hard and soft lines.

Indeed, from that time on, it was unusual to talk to Hockney without his having his tablet computer close to hand. And there is an informality to many of the iPad works that results from the fact that the gadget is always with him. The subject-matter sometimes has no real parallel in art history. What other painter has had occasion to record, as Hockney has, his naked foot beside a slipper when he got out of bed? Or his bathroom taps, with the window behind, a morning bather's view of the world, or the washing-up in the sink of the Bridlington kitchen, a glass ashtray full of cigarette butts? This was drawing as an intimate journal. But some of the preoccupations they reveal have been with him for four decades or more. That ashtray, for example, is made of clear glass. How do you draw something like that, on an iPad or in any other medium? Another drawing appeared that was a sort of visual essay on the subject.

DH The other day I sent out a drawing about transparency. I spelt it wrong so I put 'mistake' at the side. It seems to me an interesting thing to do, to draw transparency, because – visually – it's about something not being there, almost. The swimming pool paintings I did were about transparency: how would you paint water? A nice problem, it seemed to me. The swimming pool, unlike the pond, reflects light. Those dancing lines I used to paint on the pools are really on the surface of the water. It was a graphic challenge.

Four Different Kinds of Water, 1967

Some of the iPad images were entirely composed of lettering, but each word in a different style. One arrived reading 'Made for the screen, totally on the screen, it's not an illusion.' But the words themselves were acting out a little typographical drama of space and perspective – some in focus, some sharp, some apparently receding over the wavy lines, like undulating hills, that formed the backdrop, and the letters of 'illusion' itself each casting a scratchy shadow as if they were standing up in three dimensions like the giant sign that spells 'Hollywood' on the Hollywood Hills. Words in paintings – and for that matter, misspellings (Hockney has always been bad at spelling) – have been features of his work since he was at the Royal College of Art.

A complete novelty that came with the iPad, on the other hand, was that the process of drawing could be rerun at the tap of a finger. The screen goes blank again, then lines and washes reappear one after another, apparently of their own accord. The result is, in effect, a performing drawing.

DH Until I saw my drawings replayed on the iPad, I'd never actually *seen* myself draw. Someone watching me would be concentrating on the exact moment, but I'd always be thinking a little bit ahead. That's especially so in a

Untitled, 9 May 2010, No. 1, iPad drawing

Untitled, 2 December 2010, iPad drawing

Untitled, 17 April 2010, iPad drawing

Untitled, 2010, iPad drawing

drawing where you are limiting yourself – a line drawing, for example. When you are doing them, you are very tense, because you have to reduce everything to such simple terms.

MG Are you finding out things about the way you work from looking at yourself drawing like that?

DH Yes, I am. For example, I think I could be more economical.

MG Is this a new medium, or just a digitalized version of an old one?

DH This is a real new medium. You miss the resist of paper a little, but you can get a marvellous flow. There are gains and losses with everything. So much variety is possible. You can't overwork this, because it's not a real surface. In watercolour, for instance, about three layers are the maximum. Beyond that it starts to get muddy. When you know that, you've to be careful – build up slowly, working from light to dark. Here you can put anything on anything. You can put a bright, bright blue on top of an intense yellow. But you still have to think in layers as you do with lithographs, watercolours, any kind of prints. But there are other big differences in how you can work. The iPad is like an endless sheet of paper. You can adjust scale for ever. For example, I began by drawing that bowl of oranges on the table in front of us, now I've enlarged the virtual paper so that's quite small. You can go on and on adding to the drawing. First I put the oranges on a table, then in a room.

MG Now you've put the interior with the oranges on the table on an easel.

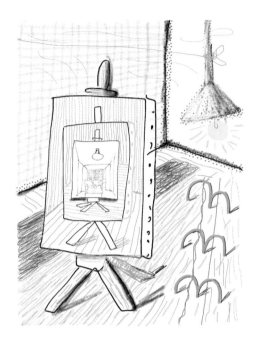

Untitled, 20 November 2010, No. 2, iPad drawing

DH Yes, and now I'm putting it on another one. [To see this drawing perform, visit www.martingayford.com or www.thamesandhudson.com.]

DH In the 1956 film *Le Mystère Picasso*, by Henri-Georges Clouzot, Picasso made paintings on glass. He cottoned on very quickly that it wasn't the finished drawing that counted. It was what was happening all along the way. All he did was keep changing it all the time in the most amazing way. Now, with an iPad you can do precisely the same thing. I've made some pictures, knowing that the process was going to be recorded. So you draw that way, using the fact that it will play back what you are doing.

Drawing on an iPad

But perhaps the most radical aspect of the iPad, and iPhone, drawings is not the way they look, or even the way they move, but the way that Hockney sends them out: they pop up – original works of art, effectively – in the inboxes of friends and acquaintances. Thus, although what he sends out is the descendant of an invention of the last ice age – handmade figurative drawings – the way he is doing it, Hockney muses, is a small token of a huge change.

DH It's not just the drawing on it; it's the way you can distribute it. That's new – very, very new. That will cause a lot of disturbance. The iPad reminds me of Michael Curtiz watching a film in an artists' café in Budapest in 1910. He was one of the inventors of Hollywood, the director of *Casablanca*. The first film he saw was in this café, and what he remembered about it wasn't the subject, but that every single person was watching it. He thought, 'Not everybody goes to the opera or the theatre, but they'll all go to the films.' He was right, they did, didn't they? Curtiz helped invent the world of mass media. And in that phrase, it's not 'media' that's crucial, it's the 'mass' part. If you take that away, you've got something quite different.

18

The power of images

Hockney looks at his iPad and sees on its illuminated screen a sign that the times are changing, and changing fast. Of course, he is far from being the only person to sense that. But Hockney's angle is unusual, because he is an artist. Like his imprisoned friend in America thought that a reference book about architecture was a history of the world, so Hockney sees history unfolding – in part at least – through the action of pictures. Many would consider ideas as the moving force that alters the human world; others, technology or economics. Hockney emphasizes the role of depictions. People, he argues, are strongly affected not just by reality, but by visual reproductions – and thus interpretations – of it.

DH Have you read *The Power of Images* by David Freedberg? It's very good. In the very first paragraph of Chapter 1 you read that, 'People are sexually aroused by pictures and sculptures; they break pictures and sculptures; they mutilate them, kiss them, cry before them, and go on journeys to them; they are calmed by them, stirred by them and incited to revolt. They give thanks by means of them, expect to be elevated by them, and are moved to the highest levels of empathy and fear.' And the point is, all those things didn't just happen in the past: it's all still true today. The influence of images shouldn't be underestimated. They always were very powerful, and always will be, and if the 'art world' retreats from them, it becomes a minor activity: the power will be with images.

MG It's easier to believe that was true in the past.

DH Do you know Flaubert's story about a servant 'A Simple Heart'? It's in *Three Tales*. She lives in the countryside in Normandy and she's only ever seen one image in a book – Flaubert mentions that. This would have been in the 1870s or thereabouts. I suppose it's possible that someone might have only seen one book then, living in a little rural place. The only other images she would have seen were in church. And if those are the only four or five images a person ever saw, those would be extraordinarily strong in her head, wouldn't they?

MG That's right. If you were living in Arezzo in 1460, Piero della Francesca's frescoes in San Francesco would have had a tremendous impact, much more than on a modern tourist.

DH Enormous. Have you ever been in Monreale Cathedral in Sicily? The mosaics are spectacular today, but they must have been unbelievably spectacular in 1200. If you went in there when the sun hit the altar with gold behind, it would have been like nothing else a person had seen then – the most modern thing, the most unnatural thing, in a world in which nature was very dominant. When the sun went down, you went to bed. There were no artificial lights. We see those mosaics as art today, but they didn't. They saw the past very vividly represented: truth.

MG And now?

DH Don't you think that television and mass media caused social changes in the twentieth century because people

saw how other people lived? If you don't know what's going on in the gated communities, why would you care or do anything? It was like that before, wasn't it? The peasants didn't know what was going on in the stately home. The moment you start seeing a little picture of it in your house, you begin to think, 'They lived a bit better; why can't we live better too?' We are all attracted to the optical projection of nature, whether in photography, the cinema, television, or the iPad. It seems the most 'realistic' picture. Yes, we agree the world looks like that – or anyway almost like that, we think – until we ask some questions. Then we might have doubts.

MG You mean about the truth of what you see?

DH Photography likes to claim that it is just putting reality in front of us. But that's obviously not the case. They started restaging battles early on, just so the photographer could get a picture of it [Eugène Appert's images of the revolt of the Paris Commune in 1870, for example]. How would anyone know? You wouldn't, unless you start asking certain questions, such as where was the cameraman? There's a famous photograph of a little boy in Northern Ireland, with an incredibly angry face. If you look at that you think, 'My God, these people are very angry.' Then there's another photograph of the boy standing there, and a row of about twelve photographers in front of him. That gives you a very different idea of the scene: the whole thing is a performance.

MG You mean, a lot of news photographs are in fact not so much truth as drama – something like an old-fashioned picture that tells a story?

DH Another example: there's a famous shot of bombed-out London the morning after a raid. There's a milkman walking over the ruins. It was made in 1941 to tell people to keep calm and carry on. But he wasn't a milkman: he was the photographer's assistant; he'd just put on a coat. You could say it was faked, but at the time it was doing a job of work: it was saying 'Carry on'. If it were a painting, you wouldn't worry about whether it was a real milkman who was the model.

MG So the medium and the technology dictate what kind of picture can be made.

DH Obviously. Susan Sontag, in her book on war photography, *Regarding the Pain of Others*, says that she was shocked to find out that the US Civil War photographer Matthew Brady had moved the corpses around to get his picture. I pointed out that she was imposing a Leica world on an era of great big, immobile cameras. I thought it was a very unintelligent view. Naturally, artists then wouldn't move the bulky camera; they'd move the object, because it was easier. Brady was just doing what other photographers were doing.

MG And the same applies to moving images.

DH Human beings obviously must be deeply affected by the optical projection of nature. We're still very attracted to it today. That's what the television picture is. One of the first authors to write about the camera obscura, Giambattista della Porta, put on what would have been like a little cinema show around 1580. He used a lens and a dark room where his friends sat. Outside, he had actors dressed up

in costumes or as animals and props. Their activity was projected onto a wall of the dark room, from the bright light outside. It was in colour and it moved. So in a way he was putting on the first movies. By the twentieth century, similar shows made with photographs – film – pulled in more people than the churches did. You went to the picture palace to see images, whereas previously, until practically 1900, you would have gone to the church to see them. In Bradford, for instance, the Cartwright Memorial Hall, a grand art gallery and exhibition space, was opened in 1904. Otherwise, the only place in the whole town you would have seen images was on hoardings; maybe the first cinema would have opened up a few years later. Twenty-five years later, when I was growing up, there were plenty of cinemas. The mass media were the creators of the world's first global stars. Charlie Chaplin became well known everywhere quickly, because of pictures. Later, you could stay at home and look at images on your television. Now you can see them on your iPad or laptop. Suddenly we're moving out of that into a totally unknown area. Young people hardly watch television. Instead, they make their own little films and send them to their friends on Facebook. They invent their own little songs and send them out. Today's babies might be the first generation brought up without stars.

MG That's not so tragic.

DH I think the deeper thing is about the shared experience. The big purveyors of images in the past were the churches. Religious institutions were providers of communal spectacle: the architecture, the ritual. Then, slowly the Church lost its social authority. Afterwards, images were

distributed by what is known as the media. Newspaper magnates, studio owners, journalists and film and TV directors controlled the pictures everyone saw. We are now witnessing another profound change. The old distributors are losing their power because there is a new technology for making and, even more important, distributing images. Last Sunday I got four newspapers delivered: the *Sunday Telegraph*, the *Sunday Times*, the *Observer* and the *Mail on Sunday*. I photographed the way they had fallen on the floor; then I weighed them. It came to three kilograms. Those have to be transported to Bridlington, then schlepped over to my house. You know that the portable computer will win; it will kill the printed newspaper. Technology brought in the mass media; now it's taking it out. Nothing else would do that.

19

Theatre

It was a perfect English summer's day in Glyndebourne, Sussex: 5 August 2010. The 1975 production of *The Rake's Progress* – an opera by Igor Stravinsky with libretto by W. H. Auden and Chester Kallman and designs by David Hockney – was being revived by Glyndebourne Festival Opera. I came down to see the dress rehearsal, but caught an early train. Hockney picked me up at Glynde station, a couple of miles away and drove back to Glyndebourne itself. This, an early sixteenth-century house rebuilt in the late Victorian style known as Jacobethan, feels like a setting for a story by P. G. Wodehouse.

In fact, since the 1930s it has been the location of one of the world's leading opera houses. Hockney is unusual among contemporary artists in having spent a long time working in the theatre, or more precisely on a series of operatic productions, first here at Glyndebourne, then for the Metropolitan Opera in New York, Covent Garden in London, and elsewhere. Not since the days of Sergei Diaghilev's Ballets Russes – which employed Picasso, Matisse, De Chirico and many others after the First World War and through the 1920s – has a major artist spent so much time designing scenery and costumes. It's the kind of work that might seem like a diversion, a bit frivolous in comparison with the serious business of art. But Hockney's opera designs are an integral part of his work. Indeed, they helped to move it forwards.

DH *The Rake's Progress* came at a good time for me because
it was a period when I was trying to figure out what to do

in painting. So when this came along in 1974 it ended something for me and took me into something else.

MG How do your opera designs connect with what you are doing in painting and other media?

DH I'd always loved the theatre. In fact, I was interested in it before I was first asked to design productions, because I'd used theatrical ideas in painting. And I'd talked about it; I said long ago that I thought of all my painting as drama. Some of my early pictures have titles such as *Theatrical Landscape* (1963). I was always interested in the theatre because it is about creating illusions in space.

MG So the stage can be very close to a three-dimensional painting.

William Hogarth, *The Rake's Progress*, 1735

An Assembly study for The Rake's Progress, 1975

DH That's why I responded to it. In the end, I spent twenty years doing about ten operas. I liked it because I was given a reasonably free hand; only I didn't do anything I didn't feel I wanted to do. I'm not a professional theatre designer. A professional theatre designer is a person who in a way takes orders. I wasn't willing to do that. I was willing to collaborate, but not just take orders. If they wanted that, they could go to somebody else.

It is easy to overlook the closeness of the link between the history of art and that of the stage. One difference is, of course, that theatrical productions are evanescent. Even photographs and films are only partial and ephemeral methods of recording them. Paintings and drawings, on the other hand, with a bit of luck and care, will last for centuries.

This fundamental difference in their survival rate obscures the fact that often in the past the very same people worked on both. Brunelleschi, the early Renaissance architect who devised those striking early demonstrations of perspective and built the cupola of Florence Cathedral in the first decades of the fifteenth century, also had time to design spectacles of sound and light, spectacular illusion and music. For the Florentine church of San Felice on the Festival of the Annunciation, he devised a 'Paradise' described by the early art historian Giorgio Vasari: 'There was seen on high a Heaven full of living figures in motion, with an infinity of lights appearing and disappearing in a flash.' For another church in Florence, Santa Maria del Carmine, Brunelleschi designed something similar: Christ's Ascension, in several scenes. According to an eyewitness, God appeared 'suspended in the air in wondrous fashion, in a great light that comes from innumerable lamps; the little boys, who represent the heavenly Powers, move around him to the sound of deafening music and sweet singing'.

So sound, lights, action – all in the mid-fifteenth century. Many Renaissance masters designed for the stage, among them Leonardo. Gianlorenzo Bernini, the great sculptor of the Baroque, was renowned for his dramatic productions, in which the effects were perhaps too spectacular. The audience apparently once fled from a staged flood of his devising, fearing they would be drowned. A pen-and-wash drawing of his survives depicting a sunrise over the sea – is this a vestige of a thrilling theatrical effect? Since the illusion of Renaissance art and the drama of the Baroque were so intimately connected with the stage, it is not surprising that Hockney – in his efforts to escape the trap of naturalism – found his way back there.

MG Obviously there are similarities between a stage and picture.

DH Theatrical design is about creating different kinds of perspective, but the perspectives can't be quite real in the theatre, because they have to be made in such a way that they create an illusion. That's why I liked designing operas, although I enjoyed the music as well.

In my design for *Tristan und Isolde*, in Act II there were three-dimensional tree trunks; but the space they were in was an illusion; they got smaller rapidly towards the back of the stage – just like the sixteenth-century Vincenzo Scamozzi's *trompe l'oeil* stage set in the Palladian Teatro Olimpico in Vicenza (1585).

MG That's very much an architectural conception, isn't it? From the auditorium it looks like long vistas of street receding into the distance from the stage, but in fact the streets are only a few metres deep. It's a brilliant false perspective.

Production model for *Tristan und Isolde, Act I: The Ship*, 1987

DH Scamozzi was an architect; Brunelleschi was an architect; and in a way the whole of linear perspective is for architecture. Really, its rules are all about buildings. You don't notice the perspective in trees and vegetation.

MG Your *trompe l'oeil* set for *Tristan* used tree trunks, which are a bit like pillars. But perhaps you couldn't have created that illusion with twisting branches, leaves and twigs, because they don't recede so obviously.

DH Exactly.

MG It's true that the original demonstrations of perspective were all architectural: Brunelleschi's *trompe l'oeil* views of the Baptistery and Piazza della Signoria in Florence. They were a little like toy theatres, peep shows, in fact. There is a deep connection between Western art and theatre.

DH Yes. Think of Poussin. Didn't he make little models of the figures in his paintings to get his lighting right? Claude's invention of putting trees on the right and left of his landscape compositions and having the deep space in the middle is theatre: it's like having flats on either side and deep space opening out in a painted backdrop behind. That's his usual way of putting a picture together.

MG Would you say that theatrical design is a matter of creating mental space – a space for the imagination?

DH Billy Wilder didn't often go to the theatre, but once Andrew Lloyd Webber did a musical version of his film *Sunset Boulevard* and he went to see it. When he came back, I asked him what it was like. He said, 'It's all *long shots* in

the theatre, isn't?' I replied, 'Yes, it is actually, unlike the cinema.' That's why you've to be a bit cautious about putting real things on stage. If you put a real tree there, the people in the front seats will be a lot closer to it than the people at the back. For them, the tree will be a long way away. Whereas, if you put *treeness* there on stage, then you can be close at the front *and* at the back. That's one reason why people are very afraid about putting nature on the stage. You have to stylize it a bit, because if you put a real thing there everyone knows their distance from it.

Shakespeare doesn't need too many designs, because his stage – the Elizabethan stage – came out at you, whereas the Italian one goes in beyond the plane of the curtain or proscenium arch as an illusion. The Globe Theatre didn't have a curtain at the front. Shakespeare is more like Cubist theatre; his text always tells you where you are, like a radio play does. You don't need much in the way of a set. When someone asked me to do a Shakespeare play, I thought there's perhaps only really *The Tempest* that I could do.

MG In a way, you started with Cubist theatre too, with *Ubu Roi.*

DH Yes, that was my first piece of theatre design. I did it in 1966 for the Royal Court in London. It was Alfred Jarry's *Ubu Roi,* and I just followed his instructions. For instance, he says don't bother with uniforms, just carry a sign saying 'This is the Polish Army'. You don't really need scenery, just put up a sign 'Parade Ground'. What I used was just letters: P, A, R and so on. Someone carried them on and left them on the stage for the length of the scene, then carried them off and put something else there. 'Ubu's Closet' or 'Ubu's Banqueting Room' were screens with the words painted on them.

Polish Army from Ubu Roi, 1966

Ubu Thinking from Ubu Roi, 1966

20

Lighting

Hockney suggested that it was time for a coffee, so we went out of the main house at Glyndebourne, bought a couple of cups in the café and found a place to sit on a bench in the gardens. At our back was a high herbaceous border; in front, a sweeping lawn with a bank of hedge and foliage; and beyond, fields and the distant, undulating downs.

It was a neat reminder of how pervasive the image of the theatre is in art and architecture. The gardens of the past – particularly in the Renaissance and Baroque eras – were not simply designed to look theatrical; they were actually used for outdoor productions and spectacles. This garden looked like a stage set; so, too, do many landscape paintings. Many of the pictures in the grand tradition descending from Claude – as Hockney had pointed out – have figures, like actors, in the foreground, trees or buildings at either side, like flats, and a deep space opening out in the middle.

The Sussex landscape, that morning, was beautifully lit by the summer sun. In northern climes especially, the sun is always changing in position, the angle of light shifting. The quality of the air between it and us fluctuates too. One day the trees may look like charcoal silhouettes, or like a Chinese wash drawing appearing through mist; in a raking dawn or sunset light, they are richly sculptural. Light doesn't just create the drama in front of our eyes; it seems inseparable from mood. Winter darkness spells depression. The brilliant sun of a summer morning, on the other hand, isn't just a symbol of elation; it seems like the emotion itself, exaltation in visible form.

MG Actually, the landscape is a sort of huge natural theatre that is being lit by the sun and the weather in an infinity of varying ways.

DH Well, it is. The clarity of early Flemish painting has always impressed me, and it has to come from their knowing the optimum lighting conditions for anything they wanted to look at. If you're looking at one thing, it might be better in the afternoon; another might be best in the morning, depending on the direction you are looking at it from.

We did a lot of filming with our nine cameras on a misty morning. The mist makes you see more. The morning when we filmed it was very rare, and very beautiful. You get a marvellous range of greens, more detail in the cow parsley. If it had been a sunny day, it would have been a little flatter. The mist is giving it something. You see layers, lovely pale greens coming through it, and many different greens in some places. A morning like that is a great rarity. The trees were wonderful shapes. You could see the sun on top and the shadows underneath, the mist is quite thin. It was beautiful. If you wait another fifteen minutes, you may not capture it. That's often true of looking at nature. For example, certain hours are best to see the volume in trees. The sun has to be very, very low to light the trunks. And you get an *intense* look at the trees, because you have deep shadows inside them. In Bridlington, it can only look like that at six in the morning, because we are on the east coast of England.

When we went to Giverny, someone was saying that Monet was always up at 5.30 in the morning. I thought, 'Well, of course he was.' Living where he was – in northern Europe – in June, it would have been foolish not to be up at five or six o'clock. The light was his great

subject. And early morning light is very special; anyone who is doing a lot of looking will be aware of that. In the winter, it wouldn't have made too much difference if he'd stayed in bed until ten.

Six years ago I wouldn't have quite understood that the position of the sun in the landscape moves throughout the year. At 'The Tunnel', for example, in the summer it's not there in the morning. It's moved north, so it's not from the same direction. All of these things you have to know; you have to know an area quite well. Constable would have known East Bergholt and Dedham in that way.

MG That makes it easy to understand why Claude spent so much time 'lying in the fields' before dawn and late in the evening. Whatever the ostensible subject, his landscapes are all about light, so all about lighting.

'Lighting' might sound a rather dry technical sort of subject. It's not the first aspect of a production of a play or an exhibition that is normally mentioned in a review. If it's good, you might not even notice it. We tend to focus on the subject, the drama. But for Hockney, lighting is crucial to many arts: photography, landscape painting, and also the staging of operas.

MG When did you begin moving to a more baroque type of theatre design, partly created by light?

DH At the time I did *The Rake's Progress*, I didn't think that much about lighting. Afterwards, when I did *The Magic Flute* in 1978, I began crudely to light the model I was working with. By the time I was working on my third production, *Parade* for the Met in New York in 1981, the lighting became part of the design instantly. *Instantly.*

The Set for Parade from Parade Triple Bill, 1980

Production model for *Tristan und Isolde, Act II*, 1987

MG How does the lighting interact with the drama?

DH For example, in the second act of *Tristan und Isolde*, according to Wagner, it's set in the garden just outside the castle. When they are singing their love duet, Isolde's maid Brangäne is on watch, and she warns that the dawn is approaching. Night is for love, and day is for duty, and the dawn comes up to spoil it all. It's a very important moment in the opera. And the music is hinting at the dawn. We had a curve of trees, which were designed so that at first the light hit only the side of each tree, and you slowly saw it moving down as well. Where would the lights go? If you hide them behind this tower, and point them at these trees, it just catches the light on each side. If it's done well and set up properly, it's a very beautiful thing. You become aware that this dawn is coming that is going to engulf them. They are singing about how the day is harsh, the night is for love. The design was all about exactly where to put the lights. Whereas when I was doing the first operas, things like that never occurred to me – although they were lit perfectly well. In the later productions, I was deeply concerned about where the source of light was going to be, and what it would do. The problem is: how can you make a deep space by using illusion? Therefore the lighting is totally part of the design, or it became it to me, because the lights control the image. That's how the audience is going to see it. At one point, Tristan sings – mixing up the senses – 'Do I hear the light?' It's a very good line.

MG It is as if the theatrical designs led you steadily out of naturalism.

Snails Space with Vari-Lites, 'Painting as Performance', 1995–6

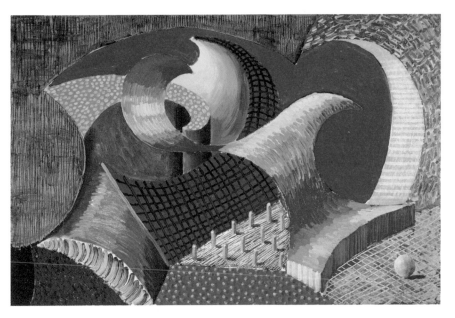

The Eleventh V.N. Painting, 1992

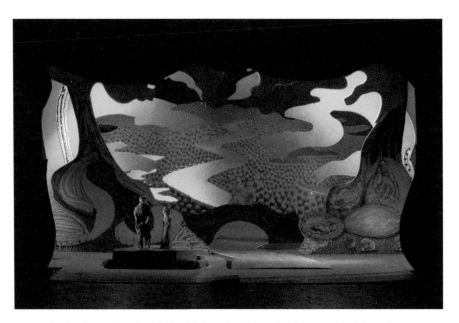

River Landscape, 1½" scale model for *Die Frau ohne Schatten, Act III, Scene IV* (Final Version), 1992

DH When we did *Tristan* in Los Angeles for the second time in 1997, we used these new things called Vari-Lites, which could change colour and move, but they'd only been used in rock concerts. You can make the shapes change by using them. My installation *Snails Space with Vari-Lites, 'Painting as Performance'* (1995–6) came out of that, it was done at the same time. It's an abstract landscape with its own lighting, like an opera set without music.

MG And your stage sets had become like spectacular, almost abstract paintings.

DH Opera *is* spectacle. I assume Wagner's *Ring Cycle* in 1876 in the special theatre he built at Bayreuth was not only a marvellous mad thing with sixteen hours of music. It would have been incredibly spectacular theatre that you wouldn't see anywhere else; just as the most extravagant theatre you'll see today is opera. There's no record of that production at Bayreuth; they couldn't make one then. I've seen the original set models, but of course they are not lighting them. And lighting is crucial. The more lighting cues you can put in, the better a production is.

MG Why?

DH The more you put in, the more variations you are going to get in the lighting. The last opera I did was Richard Strauss's *Die Frau ohne Schatten*, and the best production we did of it was in Australia. It was a very sophisticated design in terms of lighting. At Covent Garden and in LA we got it not bad; but in Australia we had an empty theatre for three weeks. No other production was going on – so we were able to put in about 350 light cues.

At Covent Garden, we had about 150. It was fantastic.
Even my utterly philistine brother saw it twice because
he thought it was terrific, and normally that work's
considered a hard sell in the opera world.

MG Do you look for a visual equivalent to the music?

DH Yes, all the productions I did in the theatre were done *with*
the music. When I was doing the production of *Tristan*
for Los Angeles in 1987 we had a model with the studio
three feet wide in my studio in LA with a lightbox. It was
like having a model train set. I'd put the music on and sit
there fiddling with the lights, following the music. It
worked when we did it in the theatre as a fantastic light
show with music.

MG What's the connection between the two?

DH It's all about light and colour. The third act of *Tristan*,
for example, is supposed to be on a cliff. There's not
meant to be much there. Tristan says how harsh it is.
I made one set in cardboard, then I decided the forms
didn't quite fit the music. It took me four or five attempts
to do it. The way the music begins seems to be about
mass and the sea and what you might be seeing: a cliff
edge, a few huge stones, a little grass. Eventually, the
design did fit the music.
 We also did a production of Puccini's *Turandot,*
and in Act III you are in a garden at night. I used deep
ultramarines, and we put blue lights on it, and it shimmered.
There were mist effects, all done just with colour. Right
at the end, it has to change back to this grand room
in the palace where they ask Turandot, 'Have you found

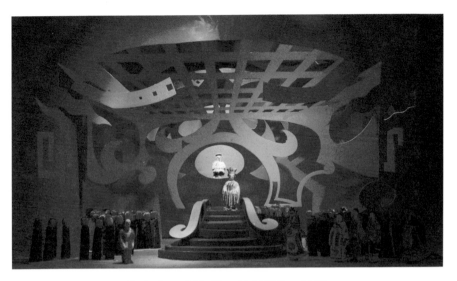

Production model for *Turandot, Act III, Scene I,* 1991

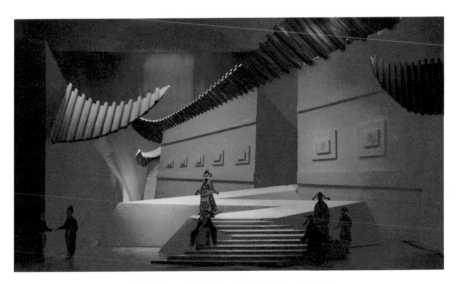

Production model for *Turandot, Act II, Scene II,* 1991

his name?', and she answers, 'His name is love.' That's it; they sing the big chorus. The palace was red, quite a brilliant red. With ordinary lights on it looked horrible. We put blue lights on it, which made it a deep purply shade. Slowly, when she sang 'His name is love', it began to change. As we put more red light on, it got redder and redder and redder. You think it can't get any redder, but it does, until the end when it just bursts. On television you couldn't do that, because there's a limit to the red that the screen can show. In the theatre, though, it works stunningly.

MG In the same way, light makes the landscape. The painter Terry Frost once set me a question: 'As the light of day fades, which is the last colour to disappear?' The answer is blue.

DH That's right. We were sitting in Bridlington the other evening, and I was talking about just that with J-P. Just then, for a short while the blues *glow*. Recently, we were at the Musée de l'Orangerie in Paris to see Monet's great *Water Lilies* late in the day, just as the light began to change, and for a short moment the subtle cobalt violets and blues he used became very intense while the sun was setting. The yellow was going out of the light at that point, so that intensifies the blues.

MG Light creates everything we see.

DH 'Let there be light!' – isn't that the start of it all?

21

Nine screens on Woldgate

It was November 2010 and I was back in the studio at the top of Hockney's house in Bridlington, now used not for painting but for viewing. We were looking at some of the nine-screen, multi-image, wide-angle, high-definition films he had shot over the previous few months, among them the misty morning on Woldgate, and some from an early autumn morning, the light rich and golden, slanting into the hedgerows and foliage of the trees. Hockney hugely enjoyed looking at these, although he had already seen them several times. He was constantly exclaiming: 'This is a road where every tree is a marvellous, different shape; it's like an exhibition of trees. Look at that wonderful pink in the sky!' There were also earlier sequences from the hawthorn season in late May and early June. The blossom lay like snow on the branches, which themselves waved against the sky, gesturing.

DH When the hawthorn blossom was at its height in late May and early June, we had two weeks of unbelievable madness. The blossom was fabulous. In Japan, there would be ten thousand cars driving around the lanes looking at it. Here, we were the only ones. People don't seem to realize blossom doesn't last long. If you are dealing with nature there are deadlines. We were doing eighteen-hour days, and I wouldn't sleep much in case I missed the sunrise. Afterwards, I collapsed and was in bed for a week, and didn't realize for days that I had a temperature. But I wouldn't have dared collapse if the blossom had still been out there. I'd have found the energy.

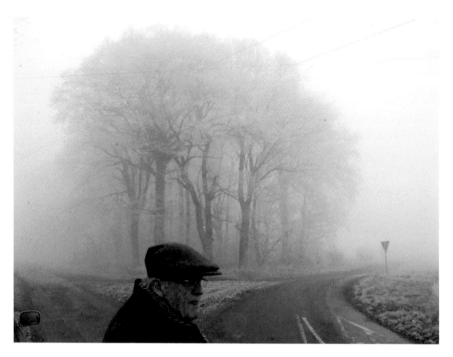

East Yorkshire, February 2008

A lot of these nine-screen images are of things floating. Around here, the best is the Queen Anne Lace and if you are driving around in a little open car, it's at your height and it seems to float in a marvellous way. We'll film it next year. Last time we were too busy with the hawthorn.

These films have become a ruling obsession at certain times of year, when a particular phase of the country calendar is at a climax. Jonathan Wilkinson has become an essential part of the team, a new sort of assistant for a novel kind of art. He was in charge of the high-definition cameras and the computer programs that run the nine- and eighteen-screen films. The

conception was quite like that of the Polaroid collages that Hockney made in the 1980s, except that this was a mosaic not of still but of moving images, and each of those screens was extraordinarily dense in detail. The subject was, in every case, moving slowing down a road, be it Woldgate or one of the other favourite locations near Bridlington. The effect was curiously theatrical. 'You see every tree individually approaching, and then they gracefully exit stage right and stage left, swirling away', as Hockney put it.

Using nine cameras overcomes quite a few of the differences between how a human eye sees and how a camera sees. It's moving, and flexible in exposure. An eye can adjust more rapidly than a camera – to different levels of light, for example. So, without trying too hard, we can look up into the bright luminous sky, then gaze into the depths of a dark bush. A single photograph can't do that. But nine separate ones can, as Jonathan explained:

> Every camera is set to a different zoom, and a different exposure. This one directed at the sky here will have been ten times brighter than this other one up there, looking into the leaves. It's like high-dynamic-range photography, but that is done by software, whereas we are doing it in a camera.

Hockney's role was to adjust all the nine images so that, rather than a fragmented jumble, they made up a roughly comprehensible scene, with a fairly consistent line going along the road. This was in fact an illusion: the cameras might be several seconds out of sync in time, and were pointing in widely diverse directions. But it worked, when you watched it, it felt like you were going down the road, now peering into the hedge, now glancing upwards as the branches arch over your head.

The author and artist with Jonathan Wilkinson and the nine-camera rig, April 2010

Jonathan Wilkinson, Dominic Elliott and the artist setting up the nine cameras, April 2010

David Hockney drawing with nine cameras, April 2010

MG So now you are working intensively with lenses again, after all your criticism of the lens-eye view of the world.

DH I was anti *one* lens. We are making a criticism of the single-camera view: that it doesn't really show us all that much. Suddenly nine involves drawing, because you have to make decisions about how you link one to the other.

MG Drawing is the central thing you always come back to.

DH Any painter would tell you that. There's a drawing basis to my Polaroid collages. There's a drawing base to this too. It lies in the way the edges of each frame relate to others. It's a matter of making a coherent space. These cameras are all pointing in different directions, some upwards. But you've got to think of all the images relating on a flat surface. After a while, I realized that with this technique you could not

'Woldgate, 7 November 2010, 11:30am' and 'Woldgate, 26 November 2010, 11am'

only draw in space, you could draw in *time*. That is, you could take an individual screen and move it on five seconds. Sometimes bits of cars appear, disappear, appear again and you realize that there are maybe seven seconds between two screens. Because it's a different time in this corner and that, when you look from one to the other you look through time. I think we see that way anyway – we do see in bits, and link one bit with another bit and another bit. The time makes the space somehow.

MG Are hand, heart and eye all in the multi-screen pieces?

DH I don't know. I've no idea whether they are art, or something or not. But they are certainly depictions of

the visible world, and not quite like any we've seen before. I think we have made something new, that has only recently become possible technologically. You can make cameras see more. Put a few together and you get a bigger and more intense picture.

Are these road pictures the end of David Hockney's search for a bigger and better picture of the world? Probably not. His investigation will go on, because the perfect picture of the world – capturing everything we could possibly see in it, and feel about it, the way we move through it and peer into it – is an impossible ideal. The quest for it, however, reveals an enormous amount, not just about pictures but also about ourselves. It seems unlikely that Hockney is ever going to give up on that.

Nine screens on Woldgate

David Hockney's life and work

1937 David Hockney is born in Bradford, Yorkshire, on 9 July, the son of Kenneth and Laura Hockney and the fourth of five children (Paul, Philip, Margaret, David and John).

1953–7 Studies at Bradford School of Art.

1957–9 As a conscientious objector, he works as a hospital orderly for his national service.

1959–62 Studies at the Royal College of Art, London, where he meets R. B. Kitaj, Derek Boshier, Allen Jones, Peter Phillips and Patrick Caulfield. His tutors include Roger de Grey, Ceri Richards, Ruskin Spear and Carel Weight. Among the visiting artists are Francis Bacon, Richard Hamilton, Joe Tilson, Peter Blake and Richard Smith. Sees works by the American Abstract Expressionists, including Willem de Kooning, Jackson Pollock and Mark Rothko.

1960–1 Takes part in the 'Young Contemporaries' exhibition at the RBA Galleries, and wins Junior Section Prize in the John Moores Liverpool Exhibition 1961, Walker Art Gallery, Liverpool. Meets the art dealer John Kasmin and Mo McDermott, who becomes his model. Reads Walt Whitman and paints *Doll Boy*, *Adhesiveness* and other love paintings.

1961 First visit to the United States. Meets William S. Lieberman, then Curator of Prints at the Museum of Modern Art, New York, who buys two Hockney prints.

1961–2 Makes series of *A Rake's Progress* etchings.

1962 Becomes friends with designer Ossie Clark. Visits Florence, Rome and Berlin with Jeff Goodman. Graduates from the Royal College of Art with a gold medal. Moves into Powis Terrace in Notting Hill. Paints *The First Marriage* and *Life Painting for Myself*.

1963 Paints *The Second Marriage* and *Play within a Play*. Completes his first shower paintings. First solo exhibition is held at John Kasmin, London, which is sold out. Commissioned by the *Sunday Times* to travel to Egypt and make drawings of the trip. In December, he goes to New York and meets Andy Warhol, Dennis Hopper and Henry Geldzahler, Curator of Twentieth-Century Art at the Metropolitan Museum of Art.

1964 In January visits Los Angeles for the first time and meets Christopher Isherwood and Don Bachardy,

Jack Larson and Jim Bridges, the dealer Nicholas Wilder and master printer Ken Tyler. Begins using acrylic paint and taking Polaroid photographs. Works on a series of stylized southern Californian landscapes and the first swimming-pool paintings. In the summer, teaches at the University of Iowa, driving across America to get there. Visits the Grand Canyon with Ossie Clark and Derek Boshier. Travels to New York for his first American exhibition at the Alan Gallery. *The Rake's Progress* etchings are exhibited at the Museum of Modern Art in New York.

1965 Teaches at the University of Colorado, Boulder. While in Los Angeles, works on *A Hollywood Collection*, a series of six colour lithographs for Ken Tyler at the Gemini workshop.

1966 In January, travels to Beirut and creates drawings for a set of etchings relating to the poems of C. P. Cavafy, which he produces back in London with the assistance of Maurice Payne. Designs sets and costumes for Alfred Jarry's production of *Ubu Roi* at the Royal Court Theatre, London.

1966–7 During the spring, teaches at the University of California, Berkeley, but returns to Los Angeles at the weekends. With *A Bigger Splash* and *A Lawn Being Sprinkled*, devises new ways of depicting water.

1967 Teaches at the University of California, Berkeley.

1968 Lives half the year in Santa Monica, working on a series of large double portraits, including *Christopher Isherwood and Don Bachardy* and *American Collectors* (*Fred and Marcia Weisman*). Returns to London in June and travels in Europe throughout the summer.

1969 Makes a series of etchings of *Six Fairy Tales from the Brothers Grimm*. He is the best man at the wedding of Ossie Clark and Celia Birtwell and begins preparatory drawings for *Mr and Mrs Clark and Percy*.

1970 First retrospective opens at the Whitechapel Art Gallery, London, before travelling to venues in Hannover, Rotterdam and Belgrade. Creates first photographic 'joiners'.

1971 Completes *Mr and Mrs Clark and Percy* after spending one year working on it. The painting is shown at the National Portrait Gallery, London.

Travels to Japan. The film *David Hockney's Diaries* made by Michael and Christian Blackwood.

1972 In London, begins the unfinished double portrait of George Lawson and Wayne Sleep.

1973 Picasso dies and Hockney produces a series of works inspired by the artist, including the self-portrait prints *The Student – Homage to Picasso* and *Artist and Model*.

1973–5 Lives in Paris. Designs sets for the ballet *Septentrion* (1974). Experiments with new printing techniques and produces *The Weather Series*, lithographs influenced by the depiction of weather in Japanese art. After a decade of working with acrylic paint, starts using oil paint again. In the autumn, Jack Hazan's film *A Bigger Splash* is released. The travelling retrospective 'David Hockney: Tableaux et Dessins' opens at the Musée des Arts Décoratifs in Paris.

1975 Designs Glyndebourne Festival Opera production sets and costumes for Igor Stravinsky's *The Rake's Progress*.

1976 Returns to Los Angeles. Begins working extensively with photography and makes large-scale lithographs.

1976–7 Reads *The Man with the Blue Guitar* by Wallace Stevens and makes a suite of twenty etchings to illustrate this theme. The autobiography *David Hockney by David Hockney* is published.

1977–8 Designs Glyndebourne Festival Opera production sets and costumes for *The Magic Flute*, a project that occupies him almost a year, during which he produces no paintings.

1978 Hockney's father dies in February. In the spring, travels to Egypt to finish work on *The Magic Flute*. Makes Los Angeles his permanent residence. On the way to Los Angeles, he stops in New York and Bedford Village in upstate New York. With Ken Tyler, he experiments with a process of moulding coloured paper pulp, and produces a series of twenty-nine *Paper Pools* prints.

1980–1 Designs Metropolitan Opera 'Triple Bill' sets and costumes for Erik Satie's *Parade*, Francis Poulenc's *Les Mamelles de Tirésias* and Maurice Ravel's *L'Enfant et les sortilèges*.

1981 Travels to China with Sir Stephen Spender and Gregory Evans, on a commission for a book, *China Diary*, for which Spender wrote the text and Hockney supplied the drawings and photographs. Designs Metropolitan Opera sets and costumes for *The Rite of Spring, Le Rossignol, Oedipus Rex* and *Paid on Both Sides*.

1982–4 Starts experimenting with Polaroid composites and making photo-collages using a Pentax 110 camera. Creates a large photo-collage of the Grand Canyon.

1983 Begins to study Chinese scrolls and reads George Rowley's *Principles of Chinese Paintings*. Designs sets for the ballet *Varii Capricci*. A photography exhibition opens at the Hayward Gallery in London and then travels to multiple venues around the world over the next four years. An exhibition of the stage sets opens at the Walker Art Center, Minneapolis, and then tours for two years in America and Europe.

1984–5 After a break of almost four years, begins painting again, producing portraits influenced by his experiments with photography. Makes 'Moving Focus' multi-coloured lithographs at Tyler Graphics in Bedford Village, New York.

1985 Designs cover and forty pages for the December issue of French *Vogue* magazine.

1986 Creates first home-made prints on photocopiers. Completes *Pearblossom Hwy., 11–14th April 1986* photo-collage, the culmination of his experiments with photography. Elected Associate Member of the Royal Academy of Arts in London.

1987 Designs Los Angeles Music Center Opera's production of *Tristan und Isolde*. Acquires a colour laser photocopier and begins experimenting with it, using it to create direct reproductions of his paintings.

1987–8 Writes, directs and features in the film *A Day on the Grand Canal with the Emperor of China, or Surface is Illusion But So is Depth*, produced by Philip Haas.

1988–9 'David Hockney: A Retrospective' opens at the LA County Museum Of Art, Los Angeles, and then travels to the Metropolitan Museum of Art, New York, and Tate Gallery, London. Returns to painting, concentrating on seascapes, potted flowers, and portraits of family and friends. Starts to use his fax machine as part of the creative process.

1989–90 Makes drawings and transmits them through his fax machines. In October 1989, he participates in the São Paulo Bienal exclusively in the form of faxed works. Makes multi-page fax pictures, using his black-and-white office laser copy machine. In November, in a live event witnessed by spectators and masterminded by Jonathan Silver, he faxes a 144-sheet composite image, *Tennis*, to the 1853 Gallery at Salts Mill, Saltaire, near Bradford.

1990 Makes colour laser-printed photographs from vacation shots of Alaska and England. Begins a series of oil paintings of the Santa Monica mountains. Using the Oasis program for Apple Macintosh, he creates his first drawing on the computer, which he prints on his laser colour printer. Experiments with a stills video camera, taking full-length portraits of family and friends. Produces two series of photographs: *40 Snaps of My House* and *112 LA Visitors*, a year-long project recording visitors to his Hollywood Hills home. Designs sets and costumes with Ian Falconer for the Lyric Opera of Chicago and the San Francisco Opera's production of Giacomo Puccini's *Turandot*.

1991 Makes computer drawings on his Mac II FX. Designs sets and costumes with Ian Falconer for Richard Strauss's *Die Frau ohne Schatten*. The Hamburger Kunsthalle in Hamburg, Germany, opens 'David Hockney: Paintings from the 1960s'.

1992 The 'David Hockney Retrospective' opens at the Palais des Beaux-Arts, Brussels, Belgium. It travels to Madrid and then Barcelona.

1993 Goes to Barcelona for the opening of the retrospective at the Palau de la Virreina. Opens an exhibition in New York of his 'Very New Paintings'. Continues research with colour laser-printed photographs from colour slides of travels to Japan, Scotland and England. Begins forty-five small portrait paintings and some drawings from life of his daschund dogs Stanley and Boodgie, which he completes in 1995. *That's The Way I See It*, the second volume of autobiography, is published.

1994 Oversees a revival of his production of *The Rake's Progress* at Glyndebourne. Creates gouache drawings and collages. Designs costumes and scenery for twelve opera arias for the TV broadcast of Placido Domingo's *Operalia 1994* in Mexico City.

1995 Produces a series of large abstract works to exhibit in Los Angeles. Paints BMW art car for the BMW art car collection. Exhibits paintings and drawings at the Venice Biennale. Opens his 'Drawing Retrospective' in Hamburg, which also travels to the Royal Academy in London later in the year. Paints still lifes and makes digital inkjet prints from photographs of paintings. Opens exhibition of still lifes and dog paintings at Rotterdam Museum.

1996 Opens his 'Drawing Retrospective' at the LA County Museum of Art in February. Creates *Snails Space with Vari-lites, 'Painting as Performance'*. Begins a series of flower paintings in oils. Travels to Melbourne to stage opera production of *Die Frau ohne Schatten*. Begins portraits in Los Angeles and continues painting portraits in England.

1997 Stages *Tristan und Isolde* revival at the Los Angeles Music Center Opera. Opens exhibition of flower and portrait paintings in London. Made Order of the Companion of Honour by HM Queen Elizabeth. Makes new oil paintings of the Yorkshire landscape. Opens his travelling photography exhibition at the Museum Ludwig in Cologne.

1998 Paintings and drawings of his dogs, Stanley and Boodgie, are published in *David Hockney's Dog Days*. Exhibits large landscape paintings at the Museum of Fine Arts, Boston. Paints *A Bigger Grand Canyon* and *A Closer Grand Canyon*.

1999 Hockney's mother dies in May. The exhibition 'David Hockney: Espace/Paysage', which traces Hockney's ideas about space and landscape from the 1960s to the present, begins at the Centre Georges Pompidou and then travels to Germany. 'Dialogue avec Picasso', the first exhibition by a living artist at the Picasso Museum, opens at the same time. A third show in the city, a version of the Museum Ludwig photography exhibition, also opens at Maison Européene de la Photographie. Exhibits etchings at Pace Prints, New York. Installs nine Grand Canyon paintings at the Royal Academy's Summer Exhibition. Sees 'Portraits by Ingres: Images of an Epoch', at the National Gallery in London. Convinced that Ingres used a camera lucida to obtain accurate likenesses, he begins to experiment with the tool. He subsequently commences research into artists' use of mirrors, lenses and other optical devices. Returns to Los Angeles and continues drawings and research. In the autumn, participates in the 'Ingres and Portraiture' international symposium at the Metropolitan Museum of Art in New York, and presents his research at Columbia University, New York.

2000 Begins writing a book about his research and theories on Old Masters' use of optical devices. During the summer, in London, begins paintings of his garden and continues work on the book.

2001 Completes the book, which is entitled *Secret Knowledge: Rediscovering the Lost Techniques of the Old Masters* and published in October. Gives lectures about his discoveries, at the Van Gogh Museum, Amsterdam, in February, and at the LA County Museum of Art in March. In the summer, travels to England, Germany, Italy and Belgium. Works with the BBC on a documentary based on *Secret Knowledge* to coincide with the publication. A major painting retrospective, 'David Hockney: Exciting Times Are Ahead', opens at the Kunst- Und Ausstellungshalle der Bundesrepublik Deutschland in Bonn, Germany, in June, before travelling to the Louisiana Museum of Modern Art, Humblebaek, Denmark. Opens his travelling photography retrospective at the Museum of Contemporary Art, Los Angeles, in mid-July, and gives lecture at the museum in August. His production of *Die Frau ohne Schatten* is performed at the Royal Opera House, Covent Garden. Exhibits paintings and drawings of his garden in Paris in November. Participates in symposium on the subject of his book and film at New York University Law School in December.

2002 Works on Metropolitan Opera's revival of 'Parade: A Triple Bill'. Begins working in watercolour while staying at the Mayflower Hotel in New York, producing a series of large multi-panel single and double portraits. Travels to London in March 2002 and sits for Lucian Freud. Travels to the Norwegian fjords and to Iceland, creating watercolours and sketchbooks of his travels.

2003 Travels to Florence to receive an honorary degree from the Academy of Fine Arts and to receive the 'Lorenzo de' Medici Lifetime Career Award'.

2004 Travels to Yorkshire to begin watercolours of the countryside. Exhibits watercolours at the Whitney Biennial. In May, travels to Palermo, Sicily, to receive the 'Rosa d'Oro' award. Exhibits a selection of Spanish watercolours at the Royal Academy's Summer Exhibition. Continues watercolours of Yorkshire through the autumn and winter.

2005 Works on a new series of almost life-size single and double oil portraits painted directly onto canvas with no pre-drawing. Exhibits Yorkshire landscapes

at LA Louver: the thirty-six watercolour studies, entitled *Midsummer: East Yorkshire*, are exhibited as one work. Returns to Bridlington and paints the East Yorkshire landscapes in oil *en plein air*.

2006 Develops a method where he can work outdoors on a large scale by using multi-canvas paintings that join to form one big art work. First exhibition of these works at Annely Juda Fine Art, London. Major exhibition 'David Hockney Portraits' opens at the Museum of Fine Arts, Boston, before travelling to the LA County Museum and the National Portrait Gallery in London.

2007 Works on *Bigger Trees Near Warter*, his largest painting to date, comprising fifty separate canvases painted outdoors and joined to form one giant picture measuring more than 4.5 metres high x 12 metres wide, which takes up an entire wall of the Royal Academy's Summer Exhibition of that year. Curates 'Hockney on Turner Watercolours' exhibition for Tate Britain, London. To coincide with the exhibition, Tate Britain exhibits a selection of five six-part Yorkshire landscape paintings marking his 70th birthday. Returns to Los Angeles at the end of December to begin rehearsals for the twenty-year revival of *Tristan und Isolde* at the Los Angeles Opera.

2008 Donates *Bigger Trees Near Warter* to Tate. Exhibits ten 'Woldgate Woods' paintings at Arts Club of Chicago. Begins to use a camera and prints to document stages of his massive multi-canvas paintings, so that he can work on location on individual canvases, yet view the work as a whole.

2009 Exhibits inkjet-printed computer drawings at LA Louver and Annely Juda Fine Art, London. Begins drawing on his iPhone. In April, travels to Germany for the opening of 'David Hockney: Nur Natur/Just Nature', an exhibition of more than seventy large-format paintings, drawings, sketchbooks, and inkjet-printed computer drawings held at the Kunsthalle Würth in Schwabisch Hall. Exhibits new paintings at the PaceWildenstein galleries in New York, his first major show in the city for more than twelve years. Nottingham Contemporary opens with 'David Hockney 1960–1968: A Marriage of Styles' as its inaugural exhibition.

2010 Starts to draw on the recently released iPad, producing still lifes, portraits and landscapes. Begins work on a major solo exhibition at the Royal Academy of Arts, London, opening in January 2012.

Further reading

Christoph Becker, Richard Cork, Marco Livingstone and Ian Barker, *David Hockney: Nür Natur/Just Nature*, exhibition catalogue, Swiridoff Verlag, 2009

Alex Farquharson and Andrew Brighton, *David Hockney, 1960–1968: A Marriage of Styles*, exhibition catalogue, Nottingham Contemporary, 2009

David Freedberg, *The Power of Images: Studies in the History and Theory of Response*, University of Chicago Press, 1989

Martin Friedman, Stephen Spender, John Cox and Dexter Cox, *Hockney Paints the Stage*, Thames & Hudson, Walker Art Center and Abbeville Press, 1983

Martin Gayford, *Constable in Love: Love, Landscape, Money and the Making of a Great Painter*, Penguin, 2007

Martin Gayford, *The Yellow House: Van Gogh, Gauguin and Nine Turbulent Weeks in Arles*, Penguin/Fig Tree, 2009

Haas, Philip (director) *A Day on the Grand Canal with the Emperor of China, or Surface is Illusion But So is Depth*, 48-minute colour film, 1988

David Hockney, *A Year in Yorkshire*, exhibition catalogue, Annely Juda Fine Art, 2006

David Hockney, *David Hockney by David Hockney*, edited by Nikos Stangos, Thames & Hudson, 1976

David Hockney, *Drawing in a Printing Machine*, exhibition catalogue, Annely Juda Fine Art, 2009

David Hockney, *Hand-Made Prints by David Hockney*, exhibition catalogue, LA Louver Gallery, 1987

David Hockney, *That's the Way I See It*, edited by Nikos Stangos, Thames & Hudson, 1993

David Hockney, *Secret Knowledge: Rediscovering the Lost Techniques of the Old Masters*, new and expanded edition, Thames & Hudson, 2006

Martin Kemp, *The Science of Art: Optical Themes n Western Art from Brunelleschi to Seurat*, Yale University Press, 1990

Helen Langdon, *Claude Lorrain*, Phaidon, 1989

Marco Livingstone, *David Hockney* (World of Art), new and enlarged edition, Thames & Hudson, 1996

Marco Livingstone and Kay Heymer, *Hockney's Portraits and People*, Thames & Hudson, 2003

Marco Livingstone, *Pop Art: A Continuing History*, new edition, Thames & Hudson, 2000

Philip Steadman, *Vermeer's Camera: Uncovering the Truth behind the Masterpieces*, Oxford University Press, 2001

Colin Tudge, *The Secret Life of Trees*, Allen Lane, 2005

Sources

p. 10 'The savants of the eighteenth century ...'
Michael Baxandall, *Shadows and the Enlightenment*, Yale University Press, 1995, pp. 24–5

p. 34 'The only art you saw ...'
David Hockney, *David Hockney by David Hockney*, edited by Nikos Stangos, Thames & Hudson, 1976, p. 27

p. 36 'We had just an hour and a half ...'
David Hockney, *David Hockney by David Hockney*, edited by Nikos Stangos, Thames & Hudson, 1976, pp. 28–9

p. 36 'When I pointed out ...'
ibid., p.29

p. 42 'Hockney and I ...'
Martin Gayford, 'A Long Lineage', in *Modern Painters*, vol. 7, no. 2, Summer 1994, pp. 21–2

p. 94 'A sort of drawn diary – a little like the one Constable made for Maria Bicknell ...'
See Martin Gayford, *Constable in Love: Love, Landscape, Money and the Making of a Great Painter*, Penguin/Fig Tree, 2009, pp. 198–200

p. 109 'this *young* lady'
John Constable's Discourses, complied and annotated by R. B. Beckett, Suffolk Records Society, vol. XIV, 1970, p. 71

p. 109 'Of course ...'
Colin Tudge, *The Secret Life of Trees*, Allen Lane, 2005, pp. 81–2

p. 133–4 'Art historians have generally been ...'
Martin Kemp, *The Science of Art: Optical Themes in Western Art from Brunelleschi to Seurat*, Yale University Press, 1990, p. 196

p. 141 'Because I hadn't seen ...'
David Hockney, *That's the Way I See It*, edited by Nikos Stangos, Thames & Hudson, 1993, p. 98

p. 151 'Claude, according to Sandrart ...'
Helen Langdon, *Claude Lorrain*, Phaidon, 1989, p. 33

p. 151 'diffuses a life and breezy freshness ...'
John Constable's Correspondence VI: The Fishers, edited with an introduction and notes by R. B. Beckett, Suffolk Records Society, vol. XII, p. 143

p. 152 'that one is the rising sun'
Helen Langdon, *Claude Lorrain*, Phaidon, 1989, p. 137

p. 166 'Although it looks ...'
David Hockney, *David Hockney by David Hockney*, edited by Nikos Stangos, Thames & Hudson, 1976, p. 61.

p. 166 'People in New York said ...'
David Hockney, *David Hockney by David Hockney*,

edited by Nikos Stangos, Thames & Hudson, 1976, pp. 94–7

p. 173 'Reference points and road signs'
David Hockney, *That's the Way I See It*, edited by Nikos Stangos, Thames & Hudson, 1993, p. 186

p. 186 'We've been right in the midst of magic'
Vincent van Gogh – The Letters: The Complete and Annotated Edition, vol. 4 (Arles 1888–1889), Thames & Hudson, 2009, p. 376

p. 201 'People are sexually aroused by pictures ...'
David Freedberg, *The Power of Images: Studies in the History and Theory of Response*, University of Chicago Press, 1989, p. 1.

p. 211 'The audience apparently once fled ...'
Charles Avery, *Bernini: Genius of the Baroque*, Thames & Hudson, 1997, p. 268

p. 211 'A pen-and-wash drawing of his survives ...'
ibid., p 269.

List of illustrations

All works by David Hockney © 2011 David Hockney
Measurements are given in centimetres, followed by inches, height before width, before depth.

2 David Hockney painting *Woldgate Before Kilham*, 2007
Photo credit: Jean-Pierre Gonçalves de Lima

7 Untitled, 5 July 2009, #3
iPhone drawing

9 *Green Valley*, 2008
Inkjet-printed computer drawing on paper, 88.9 x 118.11 (35 x 46½), edition of 25

13 *Fridaythorpe Valley, August 2005*
Oil on canvas, 61 x 91.4 (24 x 36)
Photo credit: Richard Schmidt

14 *Rainy Night on Bridlington Promenade*, 2008
Inkjet-printed computer drawing on paper, 116.8 x 81.3 (46 x 32), edition of 25

17 *Bridlington. Gardens and Rooftops III*, 2004
Watercolour on paper, 66 x 101.6 (26½ x 40)
Photo credit: Richard Schmidt

18–19 *Midsummer: East Yorkshire*, 2004
Thirty-six watercolours on paper, each 38.1 x 57.2 (15 x 22½)
Photo credit: Robert Wedemeyer

20 David Hockney painting *The Road to Thwing, Late Spring*, May 2006
Photo credit: Jean-Pierre Gonçalves de Lima

21 (*top*) Painting *Woldgate Woods, 4, 5 & 6 December 2006*
Photo credit: Jean-Pierre Gonçalves de Lima

(*bottom*) Painting in situ, East Yorkshire, May 2007
Photo credit: Jean-Pierre Gonçalves de Lima

22 (*top*) *Garrowby Hill*, 1998
Oil on canvas, 152.4 x 193 (60 x 76)

(*bottom*) *The Road to York through Sledmere*, 1997
Oil on canvas, 122 x 152.4 (48 x 60)
Photo credit: Steve Oliver

25 (*top*) *Winter Tunnel with Snow, March*, 2006
Oil on canvas, 91.4 x 122 (36 x 48)
Photo credit: Richard Schmidt

(*bottom*) *Late Spring Tunnel, May*, 2006
Oil on two canvases, each 122 x 91.4 (48 x 36), 122 x 182.8 (48 x 72) overall
Photo credit: Richard Schmidt

26 (*top*) *Early July Tunnel*, 2006
Oil on two canvases, each 122 x 91.4 (48 x 36), 122 x 182.8 (48 x 72) overall
Photo credit: Richard Schmidt

(*bottom*) *Early November Tunnel*, 2006
Oil on two canvases, each 122 x 91.4 (48 x 36), 122 x 182.8 (48 x 72) overall
Photo credit: Richard Schmidt

28 Painting *Woldgate Woods III, 20 & 21 May*, 2006
Photo credit: Jean-Pierre Gonçalves de Lima

30 *Woldgate Woods, 30 March – 21 April*, 2006
Oil on six canvases, each 91.4 x 122 (36 x 48), 182.8 x 365.6 (72 x 144) overall
Photo credit: Richard Schmidt

31 *Woldgate Woods III, 20 & 21 May*, 2006
Oil on six canvases, each 91.4 x 122 (36 x 48), 182.8 x 365.6 (72 x 144) overall
Photo credit: Richard Schmidt

33 *Bridlington July 14, 2004*
Pencil and ink, each page 14 x 8.9 (5½ x 3½)

35 *The Big Hawthorn*, 2008
Charcoal on paper, 45.7 x 60.1 (18 x 24)
Photo credit: Richard Schmidt

37 *Self-portrait*, 1954
Collage on newsprint, 41.9 x 29.8 (16½ x 11¾)

39 Sketching the hawthorn in situ, May 2007
Photo credit: Jean-Pierre Gonçalves de Lima

41 *A Grand Procession of Dignitaries in the Semi-
Egyptian Style*, 1961
Oil on canvas, 213.4 x 365.8 (84 x 144)

44 *The Cha-Cha that was Danced in the Early Hours
of 24th March 1961*, 1961
Oil on canvas, 172.7 x 153.7 (68 x 60½)

46 *Flight into Italy – Swiss Landscape*, 1962
Oil on canvas, 182.9 x 182.9 (72 x 72)

48 *Mr and Mrs Clark and Percy*, 1970–1
Acrylic on canvas, 213.4 x 304.8 (84 x 120)
Photo credit: Tate, London

49 *George Lawson and Wayne Sleep*, 1972–5
Acrylic on canvas, 203.2 x 304.8 (80 x 120)

50 *Early Morning, Sainte-Maxime*, 1968
Acrylic on canvas, 121.9 x 152.4 (48 x 60)

55 *Kerby (After Hogarth) Useful Knowledge*, 1975
Oil on canvas, 182.9 x 152.4 (72 x 60)

56 *Walking in the Zen Garden at the Ryoanji Temple,
Kyoto, Feb. 1983*, 1983
Photographic collage, 101.6 x 158.8 (40 x 62½)

59 *Grand Pyramid at Giza with Broken Head
from Thebes*, 1963
Oil on canvas, 182.9 x 182.9 (72 x 72)

60 *Play Within a Play*, 1963
Oil on canvas and plexiglas, 182.9 x 198.1 (72 x 78)

63 *Lauren, Dawn, Simon and Matthew Hockney*, 2003
Watercolour on paper (four sheets),
121.9 x 92 (48 x 36¼)
Photo credit: Prudence Cuming

66–7 *Bigger Trees Near Warter or/ou Peinture sur le
motif pour le Nouvel Age Post-Photographique*, 2007
Oil on fifty canvases, each 91.4 x 122 (36 x 48),
457.2 x 1219.2 (180 x 480) overall
Photo credit: Richard Schmidt

68 (*top*) The trees near Warter, February 2008
Photo credit: Jean-Pierre Gonçalves de Lima

(*bottom*) David Hockney sketching in situ,
March 2008
Photo credit: Jean-Pierre Gonçalves de Lima

69 (*top*) David Hockney painting *Bigger Trees Nearer
Warter, Winter 2008*
Photo credit: Jean-Pierre Gonçalves de Lima

(*bottom*) A moment of reflection in the
Bridlington attic studio, March 2008
Photo credit: Jean-Pierre Gonçalves de Lima

72 Claude Monet, *Femmes au jardin, c.* 1866
Oil on canvas, 255 x 205 (100¾ x 80¾).
Musée d'Orsay, Paris

74–5 David Hockney and friends looking at
*Bigger Trees Near Warter or/ou Peinture sur
le motif pour le Nouvel Age Post-Photographique*,
at the Royal Academy of Arts, London,
2007 Summer Exhibition
Photo credit: David Hockney and Richard
Schmidt

76 *The Atelier*, 29 July 2009
Photo credit: Jonathan Wilkinson

77 The artist mixing colours in the Bridlington
studio, March 2008
Photo credit: Jean-Pierre Gonçalves de Lima

80 Pablo Picasso, *Nude Man and Woman*,
18 August 1971
Oil on canvas, 195 x 130 (76¾ x 51¼). Private
Collection. © Succession Picasso/DACS,
London 2011

83 *Artist and Model*, 1973–4
Etching, 74.9 x 57.2 (29½ x 22½), edition of 100

84 Painting *Winter Tunnel with Snow, March*, 2006
Photo credit: Jean-Pierre Gonçalves de Lima

87 *London July 15th 2002*
Ink on paper, each page (4¼ x 6) each page
Photo credit: Richard Schmidt

91 (*top left*) Untitled, 2 June 2009, #2
iPhone drawing

(*top right*) Untitled, 13 June 2009, # 3
iPhone drawing

(*bottom left*) Untitled, 19 June 2009, #4
iPhone drawing

(*bottom right*) Untitled, 8 June 2009, #2
iPhone drawing

92 Untitled, 2 June 2009, #3
iPhone drawing

95 *Breakfast with Stanley in Malibu, Aug 23 1989*, 1989
Black-and-white laser copy, collage,
felt marker and gouache, 21.6 x 35.6 (8½ x 14)
(6 original plates)

96 *Summer Road near Kilham*, 2008
Inkjet-printed computer drawing on paper,
123.2 x 94 (48¼ x 37), edition of 25

99 *Paul Hockney I*, 2009
Inkjet-printed computer drawing on paper,
152.4 x 104.1 (60 x 41), edition of 12

103 Working on *Felled Trees on Woldgate*, 2008
Photo credit: Jean-Pierre Gonçalves de Lima

104–5 Claude Monet, *Water Lilies: Morning, c.* 1925
Oil on canvas, 200 x 1275 (78¾ x 502).
Musée de l'Orangerie des Tuileries, Paris

106–7 *The Twenty-Five Big Trees Between Bridlington School and Morrison's Supermarket on Bessingby Road, in the Semi-Egyptian Style*, 2009
Inkjet-printed computer drawing and photo collage on 2 sheets of paper, 73.7 x 546.1 (29¼ x 215)

108 John Constable, *Study of the Trunk of an Elm Tree, c.* 1821
Oil on canvas, 30.6 x 24.8 (12 x 9¾). V&A, London

111 (*top*) *Three Trees Near Thixendale, Winter 2007*, 2007
Oil on eight canvases, each 91.4 x 122 (36 x 48), 183.5 x 489.6 (72¼ x 192¾) overall
Photo credit: Richard Schmidt

(*bottom*) *Three Trees Near Thixendale, Summer 2007*, 2007
Oil on eight canvases, each 91.4 x 122 (36 x 48), 183.5 x 489.6 (72¼ x 192¾) overall
Photo credit: Richard Schmidt

112 *Felled Trees on Woldgate*, 2008
Oil on two canvases, each 152.4 x 122 (60 x 48), 152.4 x 244 (60 x 96) overall
Photo credit: Richard Schmidt

114 *Pearblossom Hwy., 11 – 18th April 1986 (Second Version)*, 1986
Photographic collage, 181.6 x 271.8 (71½ x 107)
Photo credit: Richard Schmidt

117 Camille Silvy, *Studies on Light: Twilight*, 1859
Photograph, 28.1 x 22.1 (11¼ x 8¾).
Private Collection

120 William-Adolphe Bouguereau, *The Birth of Venus*, 1879
Oil on canvas, 300 x 215 (118⅛ x 84⅝). Musée d'Orsay, Paris

122 Henri Cartier-Bresson, *Picnic on the Banks of the Marne*, 1938
Photograph © Henri Cartier-Bresson/Magnum Photos

127 Caravaggio, *St John the Baptist in the Wilderness, c.* 1604–5
Oil on canvas, 172.7 x 132.1 (68 x 52). Nelson-Atkins Museum of Art, Kansas City

132 Caravaggio, *The Entombment of Christ*, 1602–3
Oil on canvas, 300 x 203 (118⅛ x 79⅞). Pinacoteca, Vatican Museums

137 *Canyon Painting*, 1978
Acrylic on canvas, 152.4 x 152.4 (60 x 60)

138 James Ward, *Gordale Scar (A View of Gordale, in the Manor of East Malham in Craven, Yorkshire, the Property of Lord Ribblesdale), c.* 1812–14
Oil on canvas, 332.7 x 421.6 (131 x 166).
Photo Tate, London, 2011

141 J. M. W. Turner, *Yacht Approaching the Coast, c.* 1840–5
Oil on canvas, 102.2 x 142.2 (40¼ x 56).
Photo Tate, London, 2011

142–3 *A Closer Grand Canyon*, 1998
Oil on sixty canvases, 207 x 744.2 (81½ x 293) overall
Photo credit: Richard Schmidt

147 Claude Lorrain, *The Sermon on the Mount, c.* 1656
Oil on canvas, 171.4 x 259.7 (67½ x 102¼).
Photo © The Frick Collection, New York

150 Claude Lorrain, *The Tiber from Monte Mario Looking Southeast, c.* 1640–50
Dark brown wash on white paper, 18.5 x 26.8 (7⅜ x 10½). British Museum, London

154–5 *A Bigger Message*, 2010
Oil on thirty canvases, each 91.4 x 122 (36 x 48), 457.2 x 731.5 (180 x 288) overall
Photo credit: Jonathan Wilkinson

159 Federico Fellini, *And the Ship Sails On*, 1983
Film still

160 Jacques Tati, *Monsieur Hulot's Holiday*, 1953
Film still

162 Jean-Louis-Ernest Meissonier, *The Battle of Friedland 1807, c.* 1861–75
Oil on canvas, 135.9 x 242.6 (53½ x 95½).
Metropolitan Museum of Art, New York

168–9 *Santa Monica Blvd*, 1978–80
Acrylic on canvas, 218.4 x 609.6 (86 x 240)

170 *Nichols Canyon*, 1980
Acrylic on canvas, 213.4 x 152.4 (84 x 60)

172 *Mulholland Drive: The Road to the Studio*, 1980
Acrylic on canvas, 218.4 x 617.2 (86 x 243)

174–5 *The Road to Malibu*, 1988
Oil on three canvases, 61 x 243.8 (24 x 96)

177 *Pacific Coast Highway and Santa Monica*, 1990
Oil on canvas, 198.1 x 304.8 (78 x 120)
Photo credit: Steve Oliver

178 Wang Hui and assistants, *The Qianlong Emperor's Southern Inspection Tour, Scroll Six: Entering Suzhou and the Grand Canal*, 1770, Qing Dynasty (detail) Handscroll, ink and colour on silk. 68.8 x 199.4 (27⅛ x 78½). Metropolitan Museum of Art, New York

179 Canaletto, *Campo di SS. Giovanni e Paolo, c.* 1735
Oil on canvas, 46 x 78.4 (18⅛ x 30⅞). Her Majesty Queen Elizabeth II

184 Vincent van Gogh, Letter 628 to Emile
Bernard, Arles, Tuesday, 19 June 1888. Wheat
Field with Setting Sun, Leg of an Easel with
a Ground Spike.
Paper, 26.8 x 20.5 (10¾ x 8⅛). The Morgan
Library and Museum, New York.
Thaw Collection

187 Vincent van Gogh, *The Road to Tarascon with
a Man Walking*, April 1888
Reed pen and ink, graphite on wove paper,
25.8 x 35 (10⅛ x 13¾). Kunsthaus Zürich,
Graphische Sammlung

188 Rembrandt van Rijn, *Nathan Admonishing
David*, c. 1654–5
Pen and brown ink, heightened with white
gouache, 18.6 x 25.4 (7⁵⁄₁₆ x 10). Metropolitan
Museum of Art, New York

193 (*top left*) Untitled, 26 May 2010
iPad drawing

(*top right*) Untitled, 7 August 2010, #1
iPad drawing

(*bottom left*) Untitled, 6 August 2010
iPad drawing

(*bottom right*) Untitled, 31 December 2010, #1,
iPad drawing

194 (*top left*) Untitled, 13 November 2010, #1,
iPad drawing

(*top right*) Untitled, 6 January 2011, #1
iPad drawing

(*bottom left*) Untitled, 18 December 2010
iPad drawing

(*bottom right*) Untitled, 20 November 2010, #2
iPad drawing

196 *Four Different Kinds of Water*, 1967
Acrylic on canvas, 36.8 x 104.8 (14½ x 41¼)

197 (*top left*) Untitled, 9 May 2010, #1
iPad drawing

(*top right*) Untitled, 2 December 2010
iPad drawing

(*bottom left*) Untitled, 17 April 2010
iPad drawing

(*bottom right*) Untitled, 2010
iPad drawing

199 Untitled, 20 November 2010, #2
iPad drawing

208 William Hogarth, *The Rake's Progress*, 1735
Scene 2: The Rake's Levee. Engraving. Gerald
Coke Collection. Photo credit: Eileen Tweedy

209 *An Assembly study for* The Rake's Progress, 1975
Ink, ballpoint pen and collage, 50.2 x 65.1
(19¾ x 25⅝)

212 Production model for *Tristan und Isolde,
Act I: The Ship*, 1987
Photo credit: Richard Schmidt

215 (*top*) *Polish Army from* Ubu Roi, 1966
Crayon, 36.8 x 49.5 (14½ x 19½)

(*bottom*) *Ubu Thinking from* Ubu Roi, 1966
Crayon, 36.8 x 49.5 (14¾ x 19½)

219 *The Set for Parade from Parade Triple Bill*, 1980
Oil on canvas, 152.4 x 152.4 (60 x 60)

220 Production model for *Tristan und Isolde, Act II*,
1987
Photo credit: Richard Schmidt

222 *Snails Space with Vari-Lites, 'Painting as
Performance'*, 1995–6
Oil on two canvases, acrylic on canvas-covered
masonite, wood dowels, 214.6 x 670.6 x 419.1
(84½ x 264 x 135) overall
Photo credit: Richard Schmidt

223 *The Eleventh V.N. Painting*, 1992
Oil on canvas, 61 x 91.4 (24 x 36)

224 *River Landscape*, 1½" scale model for
Die Frau ohne Schatten, Act III, Scene IV
(Final Version), 1992
Foamcore, velvet, paper, styrofoam, plaster,
cloth, gouache, 215.9 x 229.9 x 121.9
(85 x 90½ x 48)

227 (*top*) Production model for *Turandot, Act III,
Scene I*, 1991
Photo credit: Richard Schmidt

227 (*bottom*) Production model for *Turandot, Act II,
Scene II*, 1991
Photo credit: Richard Schmidt

230 East Yorkshire, February 2008
Photo credit: Jean-Pierre Gonçalves de Lima

232 (*top*) The author and artist with Jonathan
Wilkinson and the nine-camera rig, April 2010
Photo credit: Jean-Pierre Gonçalves de Lima

(*bottom*) Jonathan Wilkinson, Dominic Elliott
and the artist setting up the nine cameras
Photo credit: Jean-Pierre Gonçalves de Lima

233 David Hockney drawing with nine cameras,
April 2010
Photo credit: Jean-Pierre Gonçalves de Lima

234–5 'Woldgate, 7 November 2010, 11:30am'
and 'Woldgate, 26 November 2010, 11am'
Still from 18-screen video

Note on the text

The dialogues that make up this book had their origin in a series of journalistic commissions. The first was a long interview for *Modern Painters* magazine in 2001. These continued with a succession of pieces for Bloomberg, the *Sunday Telegraph*, *Apollo*, the *RA Magazine* and the *Spectator*. Right from the beginning our talk tended to spill over the boundaries of the formal interview into something looser and more wide-ranging – to become, in other words, true conversation. Eventually, I began to record most of what was said, sometimes beginning at the breakfast table and continuing for most of the remainder of a day. All this interchange, transcribed, eventually ran to many tens of thousands of words. That is the database from which I have edited and selected *A Bigger Message*. Although the format is roughly chronological, I have often placed passages where they seemed most relevant to the unfolding argument, rather than in the precise sequence in which they actually occurred.

Acknowledgments

First and foremost I am indebted to David Hockney for the generosity with which he has shared his ideas, energy and time, and also for permission to reproduce the many works that illustrate this book (not to mention the iPad drawings that continue to arrive in my inbox almost every day). Talking to him has changed the way I look at the world around me and at pictures of it. I hope this book of conversations will do the same for its readers.

On my many visits to Bridlington, John Fitzherbert has welcomed me with warm hospitality. I've also benefited greatly from the thoughts and explanations – especially technical ones – of Jean-Pierre Gonçalves de Lima and Jonathan Wilkinson. Many of J-P's beautiful photographs appear in these pages.

David Graves, in addition to offering much encouragement, reading the text and making several useful suggestions, kindly laid on remarkable demonstrations of the camera obscura and what the artists of the past might have seen through it. That overused word 'revelation' is the only one that fits this experience. Another insight was provided by Vikram Jayanti, whose reflections on Hockney and film give a fresh angle to the book.

I am grateful to the editors for whom I have undertaken interviews with David Hockney over the years – conversations that began the process that finally turned into this book, and some parts of which are incorporated in the final text. In particular, I would like to thank Manuela Hoelterhoff, Mark Beech and Jim Ruane at Bloomberg, Karen Wright at *Modern Painters*, Sarah Greenberg of *RA Magazine*, Michael Hall at *Apollo* and Mary Wakefield of the *Spectator*.

My wife Josephine undertook the difficult task of reading early drafts and tactfully telling me what was wrong with them, and my son Tom made the index. David Godwin, my agent, was hugely encouraging about this project from the moment I thought of it. As editor and coordinator, Andrew Brown has been admirably sympathetic, while Julie Green at the Hockney Studio in Los Angeles was ever helpful in supplying images. Again, the team at Thames & Hudson, and in particular Karolina Prymaka, has done a terrific job in designing the book – on this occasion to a tight timetable.

Index

Page numbers in *italics* refer to
illustrations

A
Abstract Expressionism 43–4
abstract art, abstraction 43, 44,
47, 225
Annely Juda Fine Art, London 88
Appert, Eugène 203
Art Institute of Chicago 85
Artist and Model 83
Assembly study for The Rake's
Progress, *An 209*
Atelier, The 77
Auden, W. H. 207
Auerbach, Frank 52, 76

B
Bacon, Francis 40, 43, 44, 47,
76, 135
Bellany, John 182–3
Bellori, Gian Pietro 131
Bergson, Henri 102
Bernini, Gianlorenzo 211
Bierstadt, Albert 140
Bigger Grand Canyon, A 142
Bigger Message, A 153, *154–5*
Bigger Trees Near Warter 64–75,
65–6, 68–9, 74–5, 76, 79, 90
Big Hawthorn, The 35
blindness 10, 53
Boshier, Derek 42
Bouguereau, William-Adolphe *120,*
121
Bradford, early life in 16, 34–6, 44,
87, 90, 162, 185, 205
Brady, Matthew 204
Bragg, Melvyn 157, 163–4
Braque, Georges 166
*Breakfast with Stanley in Malibu, Aug
23 1989 95*
Bridlington and East Yorkshire *2, 6,
9,* 12–26, *13, 14, 17, 18–19, 20–1,
22, 25, 26, 28, 30–1,* 32, *33, 35, 38,*
64, *66–7,* 68–9, 76, 77, 79, *85,* 89,
91, 92, 94, 96, 97, 101, *103,* 106–7,
106–7, 111, 112, 113, 147, 156,
164–5, 185, *193,* 195, 206, 217–
18, 228, 229–35, *230, 232–3; see
also* studio in Bridlington;
Yorkshire Wolds

Bridlington. Gardens and Rooftops III
17
Bridlington July 14, 2004 33
Brueghel, Pieter the Elder 27
Brunelleschi, Filippo 58, 210, 213
Burlington House *see* Royal
Academy of Arts, London

C
camera obscura 128–35
cameras and photography, use of *56,*
57, 70, 73, 79, *96,* 97–8, 106–8,
106–7, 110, 113, 114–25, *114,*
141, 147, 156–7, 165, 180, 217,
229–35, *232–3*
cameras, lenses and photography,
theories on 32, 47, 50–3, 70,
115–35, 126–35, 140, 143,
156–65, 185–6, 202–6, 210, 231–5
Canaletto (Giovanni Antonio Canal)
134, *179,* 180
Canyon Painting 137, 141
Caravaggio, Michelangelo Merisi da
126–35, *127, 132,* 162
Cartier-Bresson, Henri *122,* 123–4,
126, 135
Casablanca 200
Caulfield, Patrick 42
*Cha-Cha that was danced in the
Early Hours of 24th March 1961,
The* 44, *45*
Chaplin, Charlie 205
Chauvet-Pont-D'Arc (cave
paintings) 39–40
Chinese art *see* Eastern art
Church, Frederic Edwin 140
Claude (Claude Lorrain) 8, 71,
146–55, *147, 150,* 213, 216, 218
Clergue, Lucien 82
Closer Grand Canyon, A 142–3,
142–3
Clouzot, Henri-Georges
Le Mystère Picasso 199
composition in painting, thoughts
on 126, 161, 213
computers and new technologies,
use of *6, 7, 9, 14,* 70, 73, 88–100,
91, 92, 94–100, *96, 99,* 106–9,
106–7, 120, 124, 146–53, *147,* 157,
163, 191–200, *193, 194, 197, 199,*
201, 206, 213, 229–35, *232–3*

Constable, John 8, 27, 29, 71, 94,
107, *108,* 109–10, 140, 151, 218
Corot, Jean-Baptiste-Camille 71
Cotman, John Sell 139
Cubism, Cubist 44, 54, 158, 166,
214; *see also* Picasso, Pablo;
Ubu Roi
Curtiz, Michael 200

D
Daguerre, Louis 93, 117, 129
David Hockney by David Hockney
(autobiography) 34, 166
De Chirico, Giorgio 207
de Kooning, Willem 43, 47
Deller, Jeremy 118
Delibes, Léo 86
Diaghilev, Sergei 207
Die Frau ohne Schatten 224, 225
Disney, Walt 23, 158
Dubuffet, Jean 43, 44
Devaney, Edith 101, 113
drawing and depiction 8, 32, *33,* 34–
40, *35, 38,* 42–3, 44, 47, 50, 54–63,
70, 73, 81, 84–5, 87, 87, 88–100,
91, 92, 96, 99, 102, 105, 116–17,
118, 124, 126, 129–31, 133–4,
140, 142–3, 157, 181, 182–90,
184, 187, 188, 191–200, *193, 194,*
197, 199, 201, 210, 211, 216, 234
Duchamp, Marcel 157
Dyck, Anthony van 128

E
Early July Tunnel 26
Early Morning, Sainte-Maxime
50, 51
Early November Tunnel 26
East Bergholt 8, 27, 29, 218
East Yorkshire *see* Bridlington and
East Yorkshire; Yorkshire Wolds
Eastern art 57–8, 62, 65, 81, 152,
178–80, *178,* 216
Egyptian art 40, 53; *see also* semi-
Egyptian style

F
Fantasia 23
Farnese Bull 53
Felled Trees on Woldgate 112
Fellini, Federico 158, *159*

films 15, 113, 115, 124–5, 156–65, 159, 160, 234–5
film-making 113, 153, 217, 229–35, 232–3, 234–5
Fitzherbert, John 15, 90, 181
Flaubert, Gustave
'A Simple Heart' 202
Fletcher, Sir Bannister 10
Flight into Italy – Swiss Landscape 46
Flynn, Errol 159
Four Different Kinds of Water 196
Freedberg, David
The Power of Images 201
Fridaythorpe Valley, August 2005 13
Friedrich, Caspar David 140
Frost, Terry 228
Freud, Lucian 23, 43, 52, 76

G
Gainsborough, Thomas 93
Garrowby Hill 22
Gauguin, Paul 86, 121, 183, 186
Giacometti, Alberto 43, 44
George Lawson and Wayne Sleep 47, 49
Glyndebourne (opera) 54, 207, 216
The Rake's Progress 207, 208, 208, 209
Gogh, Vincent van 32, 85, 86, 98, 121–2, 182–90, 191, *184, 187,*
Golding, John 52
Gombrich, Ernst
The Story of Art 52
Gonçalves da Lima, Jean-Pierre 2, 12, 15, *20–1*, 28, 32, *38*, 64, *68–9, 73, 78, 84,* 89, 97, 101, *103,* 228, 230, *232–3*
Goya, Francisco José de 188
Grand Canyon 136, 138–45, *142–3*
Grand Procession of Dignitaries in the Semi-Egyptian Style, A 41, 107
Grand Pyramid at Giza with Broken Head from Thebes 59
Graves, David 12, 128, 133, 179
Green Valley 9
Greenaway, Peter 161
Greenberg, Clement 47

H
Haydn, Joseph
Die Jahreszeiten 27
Hockney, Margaret (sister) 12, 15, 20–3, 97, 107
Hockney, Paul (brother) 97, *99*

Hogarth, William 54, *208*
Huizinga, Johan
Homo Ludens 40

I
Ingres, J.-A.-D. 189
iPad 8, 191–200, *193, 194, 197, 199,* 201, 203, 205
iPhone 6, 7, 8, 87, 88–97, *91, 92,* 187, 191, 192, 200

J
Japanese art *see* Eastern art
Jarry, Alfred 214
Jayanti, Vikram 147, 156–7
Jones, Allen 42
Juda, David 64

K
Kallman, Chester 207
Kasmin, John 42
Kemp, Martin 133–4
Kerby (After Hogarth) Useful Knowledge 54, 55
Kiss Me Kate 164
Kitaj, Roland Brooks (R. B.) 42–3
Kossoff, Leon 76

L
Late Spring Tunnel, May 25
Lauren, Dawn, Simon and Matthew Hockney 63
layers, interest in 7, 115–16, 198, 217
Leibovitz, Annie 118–19
Leonardo da Vinci 211
light, sensitivity to 24–7, 71, 79, 94, 136, 141, 152, 156, 185, 192, 195, 202, 216
lighting, use of 216–28, *220, 222, 224, 227*
linear perspective 57–8, 107, 153, 213; *see also* perspective, experiments with
linocuts 98
London July 15th 2002 87
Los Angeles 8, 16, 23–7, 62, 76, 136, 139, 141, 142, 166–78, 185, 226

M
Marques, Manuela Beatriz Mena 64
Matisse, Henri 52, 207
memory, working with 84, 101–13, 141

Meissonier, Ernest 121, 161, *162*
Midsummer: East Yorkshire 18–19
Miller, Jonathan 144
Miró, Joan 40
Monet, Claude 71, 72, 73, 85, 104–6, *104–5,* 192, 217–18, 228
Monreale Cathedral, Sicily 202
mosaic 93, 202
Mr and Mrs Clark and Percy 47
Mulholland Drive: The Road to the Studio 173
Museum of Modern Art, New York (MoMA) 116, 128–9
musical drives 176–8

N
naturalism (in art) 42–53, 54, 126, 211, 221
Nichols Canyon 171, 173

P
Pacific Coast Highway and Santa Monica 177, 178
painting 2, 8, *13,* 16, *18–19,* 20–1, 22, 25, 26, 27, 28, 28, *30–1,* 40, *40,* 44, *45, 46,* 47, 48, *49,* 50, *51,* 54, *55,* 59, 60, 62, *63,* 64–*75,* 66–7, 68–9, 72, *74–5,* 76–81, 78, 80, 84, *84,* 101–13, *103, 111, 112,* 118, 119, *120,* 124–5, 126–35, *127, 132, 137,* 140–5, *141, 142–3,* 146–53, *147, 150, 154–5,* 161, *162,* 167, 168–76, *168–9, 171, 173, 174–5, 177, 179, 196,* 208, 217, 218, *219, 223, 225; see also* watercolour
Parade 218
Paris, life in 50, 54, 61
Paris Salon 71, 121
Paul Hockney I 99
Payne, Maurice 192
Pearblossom Hwy., 11 – 18th April 1986 (Second Version) 114, 115–16
perspective, experiments with 54–61, *55, 56,* 106–7, 107, *114,* 115–16, 196, *197,* 210–14, *212, 220, 222, 223, 234–5*
photocopier, use for art 94
photography
Hockney's use of *56,* 57, 70, 73, 79, *96,* 97–8, 106–8, *106–7,* 110, 113, 114–25, *114,* 141, 147, 156–7, 165, 180, 217, 229–35, *232–3*

Hockney's theories on 32, 47,
50–3, 70, 115–35, 126–35, 140,
143, 156–65, 185–6, 202–6, 210,
231–5
Photoshop 97, 118–19, 124, 146–50
Picasso, Pablo 52, 53, 65, 80, 81,
82–4, 100, 128, 144, 166, 186,
188, 189, 191, 199, 207
Picture Emphasizing Stillness 166
Piero della Francesco 202
Play Within a Play 60
Pop art 42–3, 54
Pollock, Jackson 43, 47
Porta, Giambattista della 204–5
Poussin, Nicolas 27, 213
Proust, Marcel 87
Puccini, Giacomo 226

R
Rainy Night on Bridlington Promenade
14
Rake's Progress, The 54, 207–8, *208,*
209, 218
Raphael 126
Rechy, John 167
Rembrandt van Rijn 84, 98, 186–90,
188
Reynolds, Sir Joshua 129
Richardson, John 82
River Landscape 224; *see also Die*
Frau ohne Schatten
Road Across the Wolds, The 23
Road to Malibu, The 173, *174–5*
Road to York through Sledmere,
The 22, 23
Robin Hood 159
Rodin, Auguste 122
Rosenthal, Norman 64
Rothko, Mark 43, 80
RA Magazine 182
Royal Academy of Arts, London 44,
58, 64, 71, 79–81, 74–5, 101, 126,
129, 153, 182
Royal College of Art, London
42–4, 196
Rubens, Peter Paul 126
Ruisdael, Jacob van 58
Ruscha, Ed 142

S
Santa Monica Blvd 168–9, *170,* 173
Saville, Jenny 182
Scamozzi, Vincenzo 211–13

Self-portrait 37
semi-Egyptian style 40, *41,* 106–7,
106–7; see also Egyptian art
Set for Parade from Parade Triple Bill,
The 219
Shakespeare, William 214
Shandy Hall, Coxwold 89
sight 10, 85–6
Silver, Jonathan 23
Silvy, Camille 117, *117*
Snails Space with Vari-Lites, Painting
as Performance 222, 225
Sontag, Susan
Regarding the Pain of Others 204
space, preoccupation with 8, 15,
28, 54, 57–8, 70, 110, 115–16,
119–20, 126, 136–45, 148, 151,
153, 161, 165, 178–81, 208,
211–14, 221, 234
stained glass 93
Steadman, Phillip 130
Strauss, Richard 225
Stravinsky, Igor 24, 207
studio in Bridlington 64, *65,* 76–81,
77, 78, 89, 101, 106, 109, 147–8,
153, 156, 229
Summer Road near Kilham 96

T
Tate Britain, London
'The American Sublime' 140
'Turner and the Masters' 148
Tate Modern, London 52, 80
Tati, Jacques
Monsieur Hulot's Holiday
160–1, *160*
text-messaging 6–7, 88–9, 147,
153, 191
theatre designs 54–7, 207–14,
209, 212, 215, 218–28, *219, 220,*
224, 227
Theatrical Landscape 208
Thomson, James 27
Three Trees Near Thixendale, Winter
2007 111
Three Trees Near Thixendale, Summer
2007 111
trees 8, 27–32, 64–5, 94, 101,
109–10, 148, 151–2, 216–17,
229–31
in Hockney's work 8, *25, 26,*
28–32, *28, 30–1,* 57, *59,* 64–71,
66–7, 68–9, 73, *74–5,* 101–2, *103,*

106–13, *106–7, 111,* 211–14, *220,*
221, 229–31
Tristan und Isolde 211–13, *212, 220,*
221, 225, *226*
Tudge, Colin
The Secret Life of Trees 109
Turandot 226–7, *227*
Turner, J. M. W. 6, 8, 29, 139, 140,
148, 151
Twenty-Five Big Trees Between
Bridlington School and Morrison's
Supermarket on Bessingby Road,
in the Semi-Egyptian Style, The
106–8, *106–7*

U
Ubu Roi 214, *215*

V
van Gogh, Vincent *see* Gogh,
Vincent van
Varley, Cornelius 139
Vermeer, Jan 128, 130, 134, 179
Veronese 161
video games 86
Eleventh V.N. Painting, The 223

W
Wagner, Richard 145, 176, 178,
221, 225
Walking in the Zen Garden at the
Ryoanji Temple, Kyoto, Feb. 1983
56, 57
Ward, James *138,* 139–40
Warhol, Andy 134
watercolour 7, *17, 18–19,* 62, *63,* 97;
see also painting
Who Framed Roger Rabbit? 158
Wilkinson, Jonathan 230–1
Winter Tunnel with Snow, March 25
Wizard of Oz, The 159
Woldgate Woods, 30 March – 21 April
2006 30
Woldgate Woods III, 20 & 21 May
2006 31
Wilder, Billy 157–8, 159, 213

Y
Yorkshire Wolds 8, 20, 101;
see also Bridlington and East
Yorkshire
Yosemite 139, 140
'Young Contemporaries' 42